It's Lonely in the Modern World

It's Lonely in the Modern World

The Essential Guide to Form, Function, and Ennui from the Creators of UnhappyHipsters.com

Written by Molly Jane Quinn Illustrated by Jenna Talbott

CHRONICLE BOOKS

SAN FRANCISCO

Library of Congress
Cataloging-in-Publication Data
available.

ISBN: 978-0-8118-7928-6

Manufactured in China
Designed by TO/GO/TK

10 9 8 7 6 5 4 3 2 1

Chronicle Books
680 Second Street
San Francisco, California 94107

www.chroniclebooks.com

TABLE OF CONTENTS

Foreword by Andrew Wagner

Let us set the scene: It is the drab winter of 2010. "Modern" design, the sweetheart of well heeled, fad-following '00s aesthetes, has fallen on hard times; the once booming global economy that fueled so much consumer frenzy is mired in a mind-numbing recession; the Internet is the prime method of information dissemination and glossy home magazines are feeling the crunch; and the hipster—that peculiar amalgam of calculated cool and uncaring chic mixed with annoying irony and unceasing self-absorption—unbelievably still rules the urban playgrounds of San Francisco, Portland, Los Angeles, and New York.

It was in this setting that in late January, a new, mysterious blog authored by an anonymous duo took the design world by its Eames lounge chair and flung it to the mat. Unhappy Hipsters' original approach was simple: hijack images from *Dwell* magazine—the darling of mod-loving, cool-craving, design snobs—in order to deliver a swift kick to the groin of misappropriated modernism. Placing *Dwell*'s starkest images out of context and pairing them with irreverent captions ("It was unclear how her life had become so riddled with obvious metaphors" or "Such was his loneliness that he'd took to preparing elaborate feasts with the front doors wide open in hope that someone—anyone—would happen by") proved to be a potent combination, and Unhappy Hipsters exploded, adding a much-needed sardonic twist to the ever-changing whims of the design-consuming public.

In order to fully understand the brilliant level of irony that Unhappy Hipsters added to the ongoing design dialogue, it's necessary to take a trip back in time to October 2000 when a bright young thing of a magazine dedicated to modern architecture and design was launched. With its "Fruitbowl Manifesto," penned by feisty founding editor in chief Karrie Jacobs, the San Francisco–based *Dwell* declared all-out war on the powers that be and aimed to poke more than a little

fun at the pretentious perfections of *Architectural Digest*, *Architectural Record*, and even *Metropolis*, where Jacobs had cut her teeth for many years.

"At *Dwell*, we're staging a minor revolution," Jacobs wrote. "We think that it's possible to live in a house or apartment by a bold modern architect, to own furniture and products that are exceptionally well designed, and still be a regular human being. We think that good design is an integral part of real life. And that real life has been conspicuous by its absence in most design and architecture magazines."

But this manifesto was much more than words. *Dwell*'s assault on the buttoned-up architectural world was most effective in its photography. Painstakingly stylized interiors were replaced by sweeping shots of comparably humble (though often daring) spaces, replete with clothes on the ground, dishes in the sink, and even a ping-pong table or two. And maybe the most shocking deviation from the architecture and design magazine norm was the presence of the actual homeowners—in their pajamas, in their sweatpants, in their best stay-at-home-and-do-nothing attire—in their homes. It conveyed the seemingly obvious but oft-obscured message: Real people live here.

It was an exciting time, and I was pleased to be a part of the original rabble-rousing crew that continually shocked and awed a previously hermetically sealed profession. From our cozy confines on Osgood Alley in San Francisco's North Beach, we had, at times, too much fun hurling challenges at the status quo. But like most things, as *Dwell* grew and matured, the once rowdy start-up slowly but surely began mirroring the establishment it once mocked.

Dwell had become the old guard, the purveyors of good taste, and it was time for the elder statesmen to be challenged. It now sits at the precipice of architectural publishing—the grown-up cool kid searching for its soul in a landscape of shifting mores. Unhappy Hipsters provided a moment of relief from the pressures of perfection. A reminder that, as Karrie Jacobs stated in that very first issue of *Dwell* more than ten years ago, "We think that we live in fabulously interesting times. And that no fantasy we could create about how people could live, given unlimited funds and impeccable taste, is as interesting as how people really do live (within a budget and with the occasional aesthetic lapse)." The team behind Unhappy Hipsters might have added an addendum to that: Never, ever forget your sense of humor.

—Andrew Wagner, editor in chief, *ReadyMade* magazine

Introduction

You are about to embark on a journey that will change your life. Many people dreamily finger the pages of shelter magazines, but few possess the design acumen and forbearance to take that next step and carve out their own modern masterpiece.

It takes a hardy individual to strip down to the bare minimum of possessions required to live in a truly modern home. When you encounter the inevitable hiccups in the process or falter in your steadfast approach, remember that you are special: You are a modernist.

Modernists are a rare and superior breed of human, individuals who understand that high design gives life meaning and that the ordered luxury of minimalism is a salve that heals the weary soul. A modernist is eager to eschew the meretricious accessories that have been deemed indicators of success—enormous televisions, hand-cut crystal champagne flutes, plush carpeting, and comfortable furniture. As a modernist, you are enamored with architectural innovation. You crave a home that is a direct extension of your ego and ethos.

In this book, we will help you become modern. From chairs and cladding to children and pets, let us be your guides to a new way of living. You will allow yourself to be released from the trappings of mediocrity, to let go of preconceived notions of corporeal joy, and to take pleasure in waking up in a sepulchral bedroom. You will begin to appreciate the subtle beauty in the irregularities in a sheet of wormy plywood and to relish the tickle of walking barefoot through a gravel yard.

We will dole out practical advice and how-to insights that will make your journey to modernity as pleasant as possible. All you need is careful study and a generous budget. Soon you will become accustomed to accepting the plaudits of friends, neighbors, and strangers who envy your minimalist home. Get ready to enjoy the germination of a lifelong desire, to bask in the éclat of the great achievement of shaping your surroundings to fit your particular needs.

Welcome to the modern world.

SECTION 1: INTERIORS

It's no coincidence that the journey to modernity begins indoors. We spend our days at computers, our nights in front of the television, and though we may profess to be nature lovers, organic gardeners, and erstwhile outdoor hobbyists, the truth is that our lives are lived indoors, cocooned in the luxuries of the bourgeoisie—espresso machines, heated towel racks, and high-thread-count sheets.

Shunted from work to home and back, there is precious joy in cultivating our domestic surroundings. But navigating the vast sea of choices for modern living can be daunting. When your home space is so vital, there is no threshold for failure.

Precious few are fortunate enough to browse fittings and furnishings catalogs with the shrewd eye of an interior designer or the rigor of a minimalist architect, yet there is no remedy for the crippling embarrassment of purchasing a complete kitchen from a discount showroom. That's where *It's Lonely in the Modern World* comes in.

In this section, we reveal the choices, techniques, and materials that will create a vibrant modern home. It may require a bit more effort and study, but ultimately the DIY approach outlined here yields greater rewards. We'll walk you through the elements of a well-appointed modern home. From the cold reflective surfaces of walls, floors, and countertops, to the high-end whirring appliances in your stainless-steel kitchen, to the best methods for illuminating a windowless room, you'll learn how these elements combine to achieve the modern ideal.

Discover how to assemble the most mono of monochromatic color palettes, how to achieve the elusive open floor plan, and how a surfeit of design challenges can easily be solved with plywood. Soon you'll be comfortable tossing around terms like "distressed" and "reclaimed." Antique family heirlooms and tragic IKEA dorm decorations will give way to rooms filled with vintage and po-mo furniture, or, if you so choose, cavernous rooms filled with nothing at all. And should all else fail, you'll learn how exposed ductwork can solve nearly any design flaw.

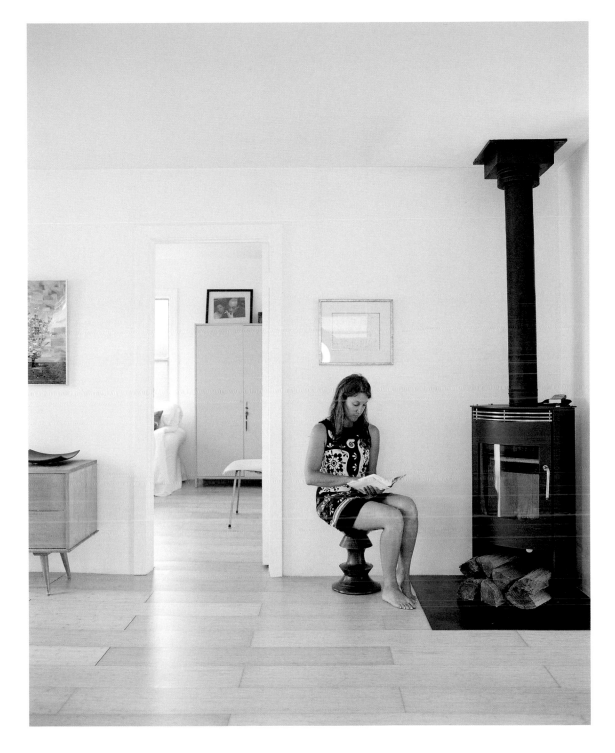

CASE STUDY #196

"Even the Eames stool understood that the only time he was awkwardly perched upon was when company came."

Form follows function.

LOUIS SULLIVAN (1856–1924)

The grandfather of modernism, the creator of the skyscraper, Frank Lloyd Wright's mentor—this guy had it all. He coined "Form follows function," which has become the anthem of architects worldwide. By the early 1900s, Sullivan's work had fallen from fashion and he descended into a vicious spiral of alcoholism and financial trouble. He finished his career designing a series of small commercial banks in the Midwest before dying alone and destitute in a low-rent Chicago motel.

⊙ Notable Works: Nearly all of his skyscrapers were demolished. Only the banks remain.

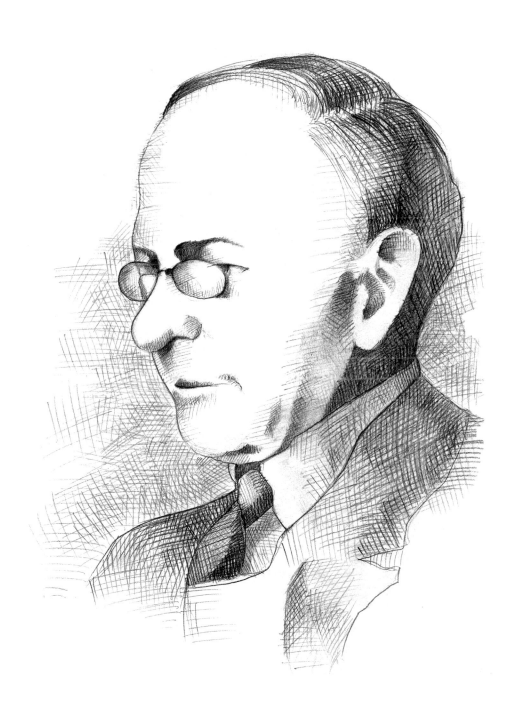

SURFACES

Devoid of extraneous embellishment, the best neo-modern houses derive their character from carefully chosen surface materials. Smooth or textured, cold stone or warm wood, natural or man-made, each type of flooring, countertop, and wall treatment speaks volumes about you and the experience that visitors will have upon entering your home.

You could pack your rooms with five-figure furniture and accessories from Design Within Reach in hopes of creating a haven of minimalism, but the truth is, it's the negative space—the shapes and silhouettes of furniture and accessories that *aren't* there, the items you've nobly ejected and rejected—that reveal you to be a person of taste and substance. Only what is left behind matters.

With few furnishings to distract, the eye is drawn to the base elements of the rooms. The best surfaces are utilitarian, hard, and, ideally, monochromatic. A no-fail formula? The winning combination of plywood and concrete. As you'll learn in the following pages, these two simple yet versatile materials can never be overused.

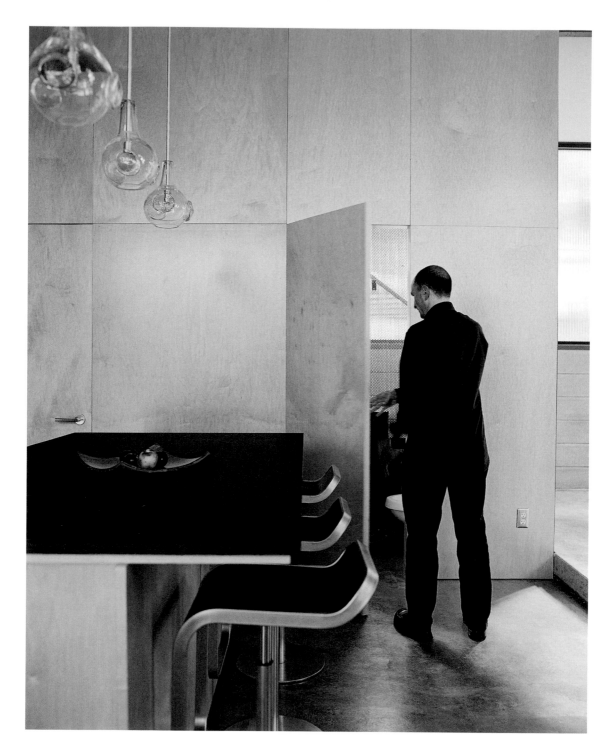

CASE STUDY #88

"He finally decided to eliminate the one thing that blemished the uninterrupted expanse of concrete and plywood—himself."

Wooden Expression

Manufactured plywood is a natural choice for walls, floors, ceilings, cabinetry, and custom furniture. The material you're familiar with is essentially a veneer atop pressed layers of pine, hence the "ply" in plywood. (It is not to be confused with MDF, or medium-density fiberboard, which is a pathetic amalgamation of shredded scrap wood commonly used to make cheap ready-to-assemble furniture.) You'll find endless finishes with varying colors and textures, including alder, arbutus, ash, Baltic birch, bamboo, cedar, cherry, hickory, mahogany, maple, and redwood. As tempting as the rich tones of mahogany may be, think of your parents and the espresso-stained flooring in their empty-nester condo. Be exceptional, go against the grain— choose the unadulterated natural tones of knotty pine.

You can find three basic types of knotty pine plywood available at lumber yards.

GRADE A is smooth. It can be painted (although we really, really recommend against it) and features jagged patches over particularly blemished areas.

GRADE B is solid and has more wormy knots. The best pieces may even have very minor splits.

FIN-PLY is what manufacturers call Finnish plywood. It is usually more durable and attractive than generic plywood. While many plywood products are inexpensive, Fin-Ply actually costs quite a bit. However, the high cost of Fin-Ply is tempered by the desirability of its origin: Finland.

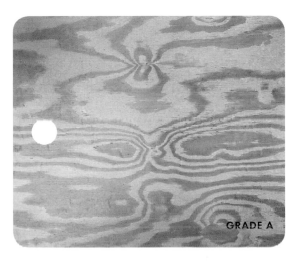

GRADE A

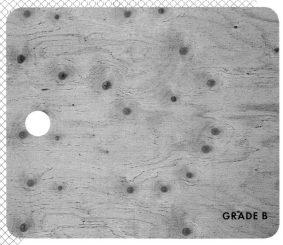

GRADE B

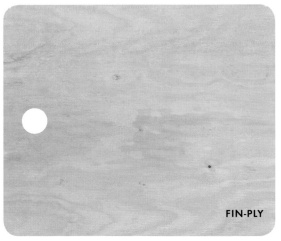

FIN-PLY

Architecture is the learned game, correct and magnificent, of forms assembled in the light.

LE CORBUSIER (1887–1965)

Charles-Édouard Jeanneret-Gris, a.k.a. Le Corbusier, was a Swiss French artist who came to personify the International style. He formally took on the pseudonym "Le Corbusier" in the 1920s, when it was fashionable to go by a persona; it seems to have been a derogatory nickname that he adopted. He had an affair with Josephine Baker (or at least he sketched her in the nude while they were traveling on an ocean liner, à la *Titanic*) before marrying a model and taking on an heiress as a mistress. In his later years, he became very involved in conceptual urban planning. At seventy-seven, his body was found in the Mediterranean Sea by bathers, after he suffered an apparent heart attack.

⊙ Notable Works: LC4 chaise longue. Villa Savoye, France. LC2 armchair, loveseat, sofa.

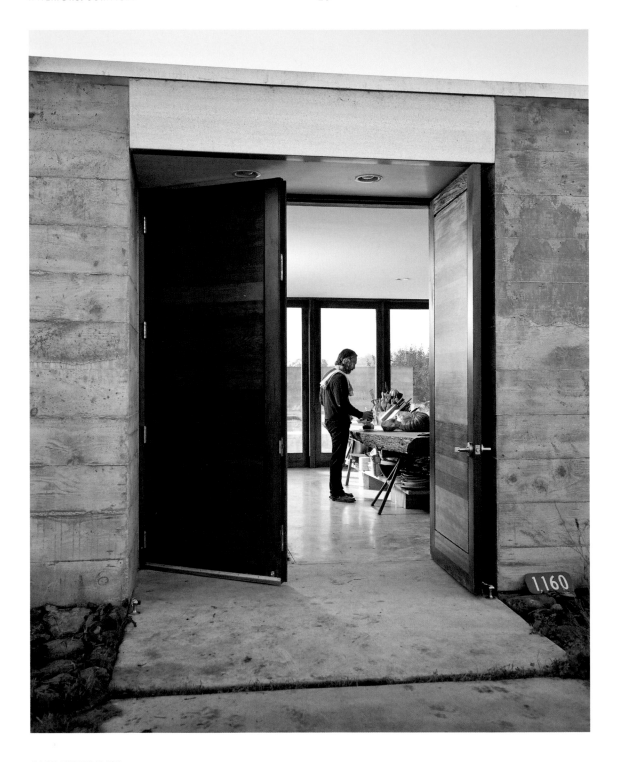

CASE STUDY #409

"Such was his loneliness that he'd took to preparing elaborate feasts with the front doors wide open, in hopes that someone—anyone—would happen by."

Beauty Underfoot

Concrete is endlessly versatile. No other material is so well suited to a modern abode. Not only ideal for flooring and countertops in the kitchen, it's equally compelling when used in the bath, the backyard, and the bedroom or nursery. Although it can be tinted to any shade, from fire-engine red to Starbucks green, the original grayish concrete is the most desirable and comes in a wide array of subtle hues. Here are a few of the most sought-after colorways. If you can't find these exact shades, bring these chips to your local concrete mixer for a color match.

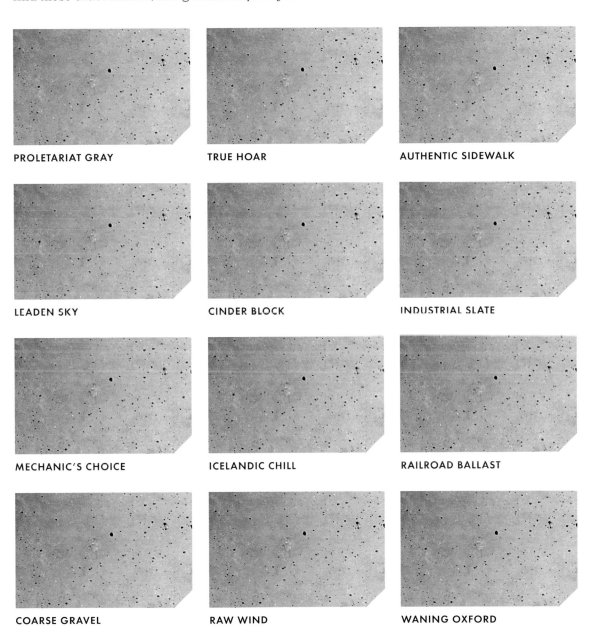

PROLETARIAT GRAY TRUE HOAR AUTHENTIC SIDEWALK

LEADEN SKY CINDER BLOCK INDUSTRIAL SLATE

MECHANIC'S CHOICE ICELANDIC CHILL RAILROAD BALLAST

COARSE GRAVEL RAW WIND WANING OXFORD

Ceramic/Glass Tile

Made from natural clay or ground glass and then, in the case of ceramics, covered with a glossy or matte glaze, tiles are water resistant and easy to wipe clean. For an authentic vintage look you'll find that using California-based Heath Ceramics' tiles is essential.

Cork

The cork tree (*Quercus suber*) can live up to 250 years, producing its first batch of cork (bark peeled off of the tree) after 25 years and then being harvested every decade or so thereafter. It's possible to find cork flooring made from recycled wine corks, but easy enough to pass virgin cork off as reclaimed. It's kind of squishy underfoot.

Bamboo

A fast-growing grass that looks and wears like hardwood, bamboo shoots are harvested and then pressed together to create a striated pattern that can be laid over subflooring. Snap-together models can be placed on top of existing offensive parquetry with minimal difficulty.

⊕ **PROS:** Inexpensive ceramic subway tile in a bathroom or on a kitchen backsplash creates an antiseptic atmosphere.

⊖ **CONS:** Tile can present as a predictable and unoriginal choice. Plus, anything other than white or puce or pure cyan appears trite.

⊕ **PROS:** This renewable resource offers a pleasing irregular pattern and it's antimicrobial for obsessive compulsive-disordered modernists.

⊖ **CONS:** It's not plywood.

⊕ **PROS:** Environmentally friendly bamboo imbues rooms with organic credibility. It comes in a huge variety of stains, from blonde to espresso.

⊖ **CONS:** It's not plywood.

Linoleum

An all-natural product, linoleum is made from a combination of linseed oil, rosin (pine resin), cork dust, limestone, wood flour, and pigments. Usually the sheets feature a jute backing. Home dwellers get extra points for using Swedish brands such as Forbo and referring to it as "Marmoleum."

Stainless Steel

The go-to for an industrial look, stainless steel isn't actually steel. Instead, it's made from nickel and chromium. Austenitic steel is more flexible due to a higher nickel content, while ferritic steel is more impervious to corrosion and better suited to interior architecture.

Engineered Stone

Composite stone is made using everything from recycled glass to aggregate granite chunks or quartz and held together with resin. Unlike sheets of natural granite, composites are unlikely to off-gas radon—but huffing the sealant will afford a comparable high.

Adobe

Also known as an earthen floor, this mixture of clay, sand, and straw is laid in three layers, starting with a thick base and ending with a topcoat of perilla oil. Installation can take up to a month. Custom tints range from concrete gray to burnished brown.

RIALS

⊕ **PROS:** Linoleum flooring is relatively cheap and easy to clean. Dings and cuts can be resealed, making it a good surface for heavily trafficked rooms.

⊖ **CONS:** Could unironically skew 1940s kitsch.

⊕ **PROS:** Shiny and slick, nonporous and nonstaining, stainless steel is an excellent choice for areas where you wouldn't expect it (the bed of a child's crib, for example).

⊖ **CONS:** None. (Except you can't cut food on stainless steel counters and it is an electrical conduit, so electrocution is always a possibility. It's also noisy, expensive, and susceptible to dents and scratches. Still, it's worth the investment.)

⊕ **PROS:** Composites are incredibly durable and heat resistant, making them ideal for the adventurous cook.

⊖ **CONS:** It can easily be mistaken for cliché spec-home granite.

⊕ **PROS:** Finding an expert to lay an adobe floor is nearly impossible, lending this technique extra cachet. It's pleasingly expensive to install and won't fade in the sun.

⊖ **CONS:** It cracks and blisters, making it unreliable for humid or arid climates, kitchens or bathrooms, and high-traffic areas such as hallways, bedrooms, living rooms, basements, or children's rooms.

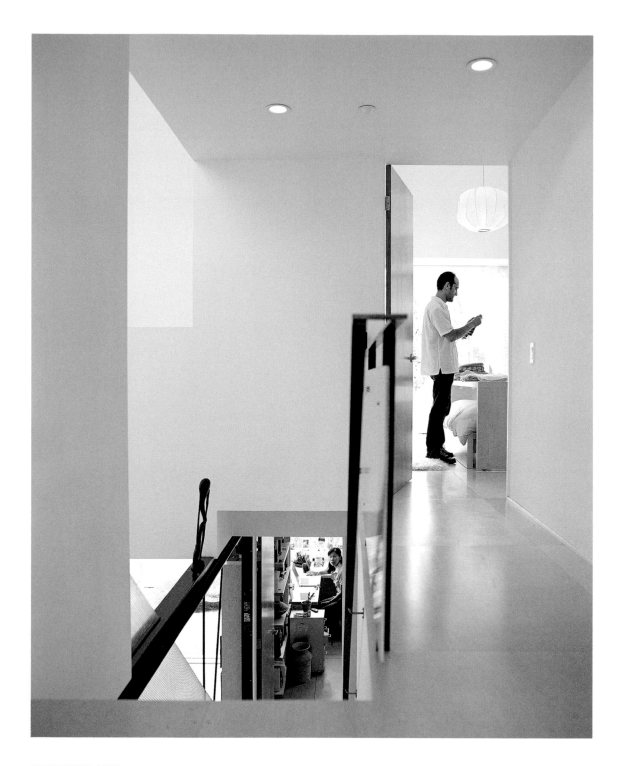

CASE STUDY #741

"They'd lived this way for years; each existed on their own level, emotionally and physically separate."

LIGHTING

There is quiet beauty in the interplay between light and shade. But finding the balance between the numbing fluorescent illumination in your cubicle and the dark emptiness of life's unmet expectations is tricky. Our built environments are so painstakingly artificial that we cannot afford to leave interior illumination up to nature. For maximum contrast, turn up the volume on structural lighting. With luck (and the right sources), you can create a lighting scheme that offers unwavering, blinding brightness.

Sconces, pendants, chandeliers, lanterns, surface-mount, recessed, cove, pull chain, and dangling bare bulbs—you'll find a seemingly limitless sea of choices for overhead lighting, both good and bad. And yet, the reality is that few are suitable for modern living. By far, there is none worse than track lighting. Although positionable and capable of highlighting specific objets d'art, track lighting smacks of retail vernacular—or, worse yet, a generic condo alongside a highway in Nowheresville, USA. If you take nothing else from this section, it should be that track lighting is to be avoided at all costs, even if it means eschewing electrical lighting altogether and spending your evenings in (literal and metaphorical) darkness.

We've found that the best lighting in a contemporary home is manufactured and minimalist. The white walls, light-colored floors, and sparse furnishings of a modern home demand high-wattage, bare bulbs. In this section, we'll show you how to find exactly the right fixtures for your particular style of modern living.

Hanging Loose

When designing an overhead lighting scheme, you want to aim for an uninterrupted plane in the form of a ceiling that stretches on for miles (save for a few exposed steel U beams or exposed ductwork—see page 78). Nothing ruins an expanse of serene ceiling quite like a hulking fixture. So how do we achieve the bright, sun-bleached rooms that are so synonymous with contemporary architecture without undermining the integrity of the overall design?

A ceiling-mounted fixture should only be used as a sculptural focal point, not to deliver illumination. Once the interior has been wired with subtle recessed lighting, you can turn your attention to the important matter of finding a spectacular fixture that does little to illuminate a room, but does everything to support the overall design schema.

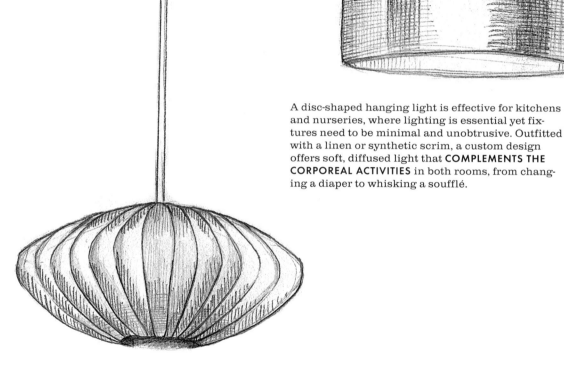

A disc-shaped hanging light is effective for kitchens and nurseries, where lighting is essential yet fixtures need to be minimal and unobtrusive. Outfitted with a linen or synthetic scrim, a custom design offers soft, diffused light that **COMPLEMENTS THE CORPOREAL ACTIVITIES** in both rooms, from changing a diaper to whisking a soufflé.

Taking a cue from paper Chinese lanterns, George Nelson's plastic "saucer" lamp is an obvious choice. However, the silhouette of this shade takes on a casual sort of glamour when rendered in cloudy, hand-blown glass. Companies like Niche Modern, run out of New York by designer Jeremy Pyles, balance the sensuality of the form with the integrity of glass in a series of earthy hues that **CAST THE PERFECT PALL** on concrete and plywood surfaces.

This design by architect Poul Christiansen may look like a **WAD OF CRUMPLED, FOLDED PAPER,** but after it was introduced in the early 1970s, it quickly became a classic. As with anything, its success bred imitators, most notably IKEA's very sad Knappa pendant. Integrating it into a modern interior without teetering on the verge of cliché is tricky. Overall, we recommend using this design as a last resort.

PRACTICAL CONSIDERATION

Ever notice how the homes featured in magazines are flooded with bright white light? Even the ones with few or no windows? For years, interior designers, architects, and stylists have relied on tiny bulbs that were, until now, available only to the trade. Industrial-strength light-emitting diode (LED) bulbs are perfect for casting a harsh glow. Sold behind back counters at luxury lighting retailers across the country, these are blue/ultraviolet (UV) diodes coated with yellow phosphor that illuminate rooms with a cold, bluish hue. Ask shop owners to show you the "blue bulbs" and expect to pay upwards of $45 each.

⊙ **NOTE:** UV rays may leak and cause cancer and/or vision loss.

The domed pendant works well in large living rooms with cathedral ceilings or in a graduated series dangling from the ceiling of a staircase. The **EXPOSED INTERIOR OF THE BOWL** offers a flood of bright light. It's most effective when executed in an industrial material, like Peter Bowles's 1940s aluminum design, that commands a visitor's attention.

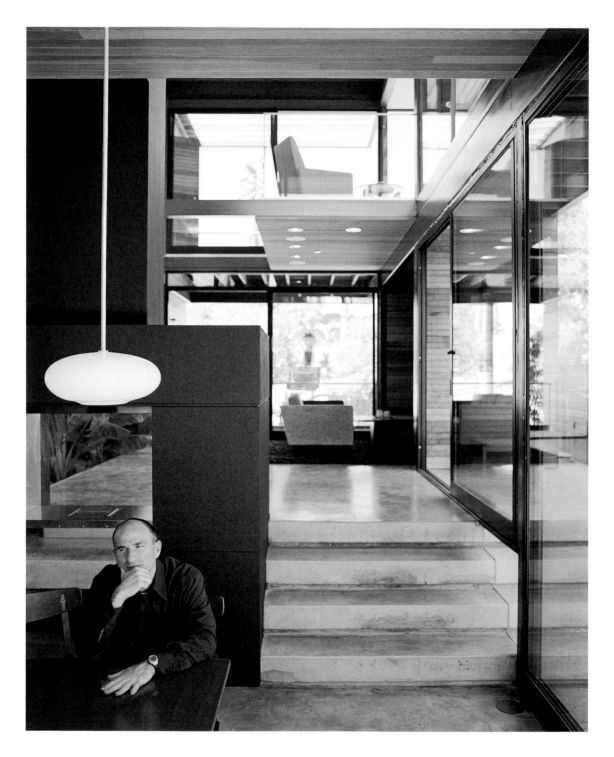

CASE STUDY #918

"He quietly contemplated the disconnect between his social ineptitude and impeccable aesthetic."

Detail Oriented

As lovely and blinding as blue bulbs are, they can cause
eye strain when it comes to detail-oriented tasks. For home-
office projects such as cutting paper with utility knives,
sorting pushpins, compulsively sharpening pencils, or read-
ing Kant, Proust, and Hornby, we recommend the following
desk models.

LEAF PERSONAL LIGHT designed by
Yves Behar for Herman Miller

Place directly over the task, directed
downward to limit glare (careful not
to slice open your hand on the
sharp metal).

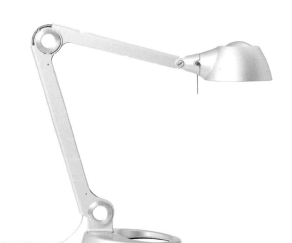

COPELAND LIGHT designed by
Stephen Copeland for Knoll

A rounded shade provides sufficient
ambient light for small projects and is
best placed to the left of the task.

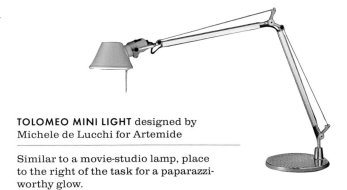

TOLOMEO MINI LIGHT designed by
Michele de Lucchi for Artemide

Similar to a movie-studio lamp, place
to the right of the task for a paparazzi-
worthy glow.

It doesn't cost money to light a room correctly, but it does require culture.

POUL HENNINGSEN (1894–1967)

Henningsen is best known for his sculptural lighting, but few know of his role in Denmark as political author, documentarian, sexual liberator, and all-around provocateur. The bastard son of Danish journalist and satirist Carl Ewald, he was considered a left-wing cultural touchstone for the country between World Wars I and II. In exile during World War II, he fought the Nazis with strongly worded protest poetry.

❍ Notable Works: PH Lamp. PH5 Lamp. PH Artichoke Lamp.

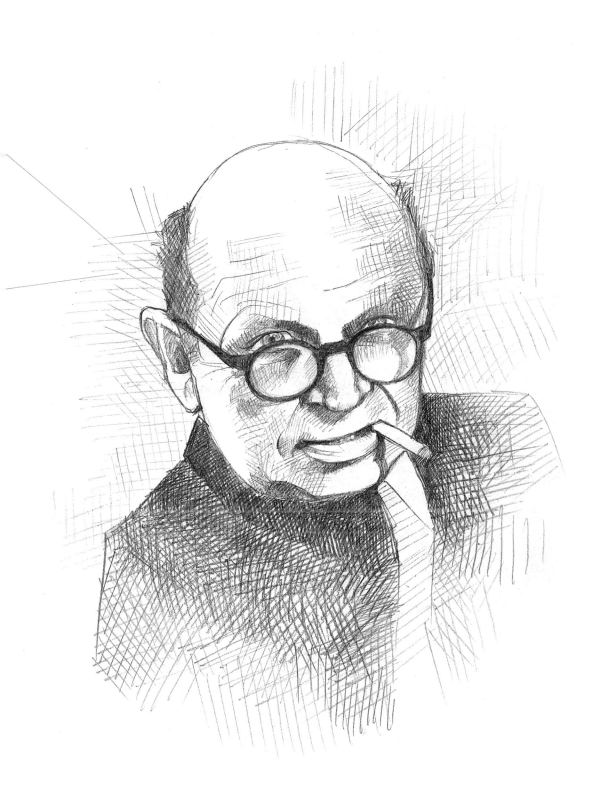

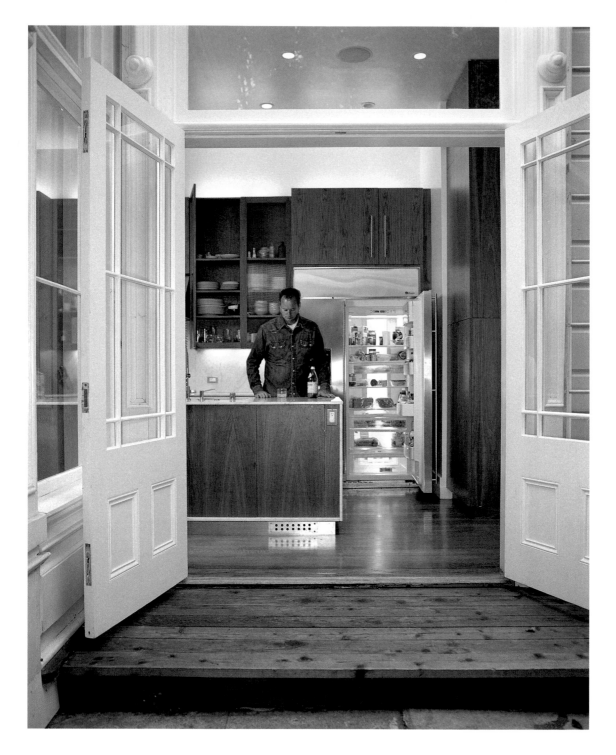

CASE STUDY #26

"Compulsively throwing open the doors, cupboards, and fridge—
the shame of life as a culinary flasher."

KITCHEN

There's truth in the saying "the kitchen is the heart of the home"—but not for the modern home. In a modern home, family and friends don't gather in the kitchen to feast on mama's meatballs; instead, they gather to admire your financial investments, from gleaming stainless-steel professional-series appliances to shiny marble counters.

It's here that you indulge in the comfort of unattainable culinary exploits and overwrought dinner parties populated by the most influential personalities you know. Clean lines and open shelving soothe, while the utilitarian simplicity of the devices lend authority to the room. Take a moment now and then to peer into a cupboard and sigh at the beauty of an expanse of pristine copper-core stainless pots and pans.

Geometry is the driving force of a properly planned kitchen. In the age of Whole Foods Markets and $30-a-pound truffled Gouda, it's impossible to get by with a simple electric burner and a microwave. Instead, the kitchen must include a six-burner restaurant-grade cooktop for simmering sauces, a deli-style meat slicer for paper-thin prosciutto, and a bevy of electronics that all work toward brewing the most perfect thimble of Cuban espresso. As far as the layout of the room is concerned, follow the golden rule of three: When the chef is standing at the center island, visitors must be able to see at least three rare and expensive cooking devices.

Surfaces are best unsullied by organic matter such as food. Keep in mind that cooking doesn't actually need to happen—it's actually advisable that it doesn't—but the design must imply that it could. You can warm up a stark kitchen with a small bowl of citrus or a glass vase holding a few spindly grasses. But before such decorative measures can be considered, it's imperative that you create a strong foundation in the way of a purposeful layout. And, most important, expect to allocate all available funds to this area, whether for new construction or renovations.

The Kitchen Checklist

Here you'll find the essential elements of a modern kitchen.

1. COUNTERS

Consider whether you will use the counter for food preparation. If your material of choice isn't food safe, simply stop preparing meals at home. It's worth it (and food packets are notoriously crude).

2. REFRIGERATOR

Although a large fridge is tempting for stashing away those farmers' market finds, weigh the pros (storage capacity) against the cons (hulking size) and settle for a discreet under-counter mini fridge. It may be impossible to fit everything you need into the diminutive cooler; move produce and meats to an auxiliary basement fridge and stock this smaller one with rare unfiltered sake.

3. LIGHTING

An overhead fluorescent light offers more than enough illumination. Pendant lights above the island should be used sparingly to avoid interfering with sight lines.

4. PANTRY

What is this, the Depression?

5. COOKING APPLIANCES

Gas ranges only, preferably Viking. If you must have a microwave or toaster, keep it out of sight. Hide it behind a custom plywood panel at the farthest corner of the room. The oven hood should either be a premium stainless model, a curving armature hovering over the entire cook station, or a mechanized device that retreats into the cabinetry when not in use.

6. COOKWARE

Although premium pots and pans should not be stored in view, they make a worthy investment for whipping up antipasti. Choose only the best brands: All-Clad saucepans and pasta pots, Le Creuset casseroles and Dutch ovens, Mauviel copper pans. Nonstick is not an option.

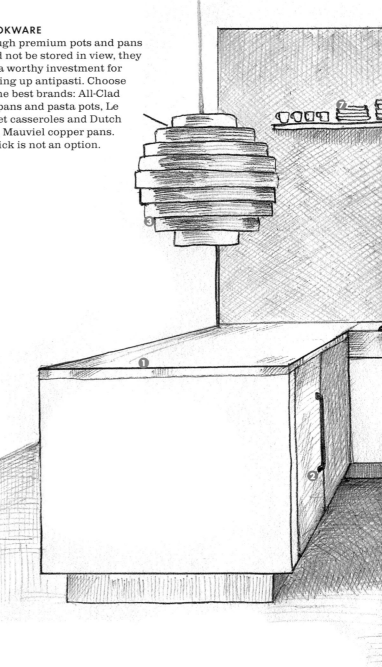

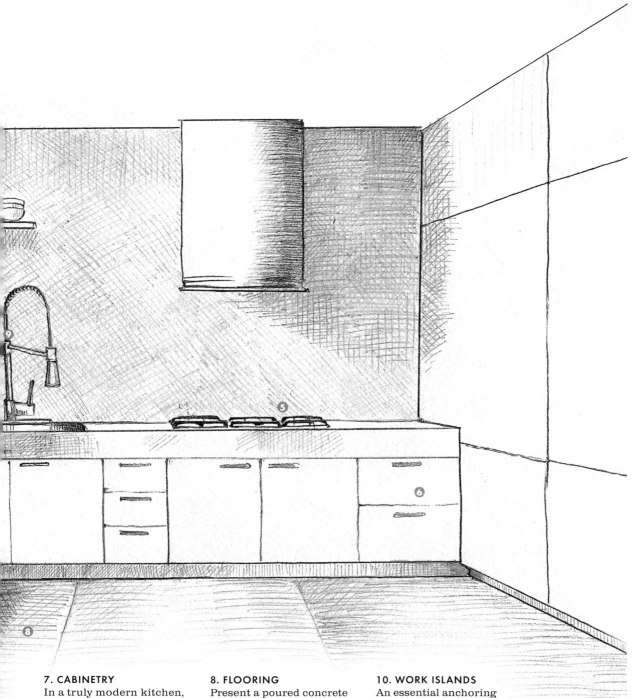

7. CABINETRY
In a truly modern kitchen, storage is always at a premium. However, aesthetics should never be compromised in favor of utility. Above-counter cabinets are shamefully conventional. If you can't display your dinnerware on open shelving, it's time to reevaluate your collection.

8. FLOORING
Present a poured concrete floor (refer to page 21 for colorways).

9. SINK + FAUCET
A pull-out faucet adds an air of industrial authenticity to the kitchen. Double sinks are pedestrian and should be avoided.

10. WORK ISLANDS
An essential anchoring element, there are three main configurations for a workable kitchen island. See page 37 for details.

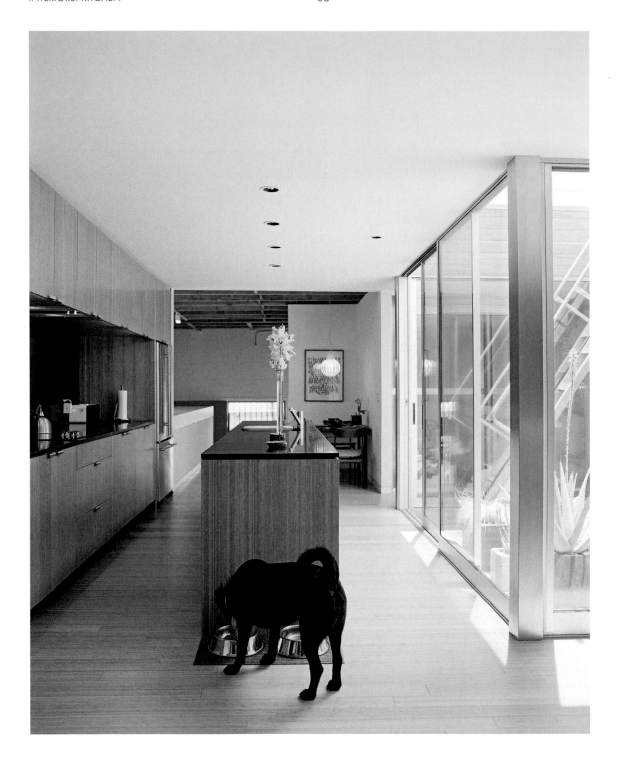

CASE STUDY #12

"The only action the kitchen saw was of the canine variety."

Island Life

A center island acts as an anchor in the kitchen, serving myriad purposes for the home cook. Before you invest in installation, consider exactly how you'll use it. Do you want to encourage guests to belly up to the bar while you man the range? If so, we recommend extending the countertop material over one edge to create space under which you can tuck stainless-steel Bertoia stools. If you (admirably) would rather discourage guests from encroaching on your personal space, forgo the counter bar in favor of thick stone or concrete wrapped over the blocky island and extending down two sides.

TYPES OF ISLANDS

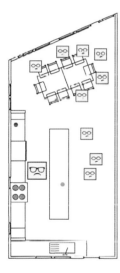
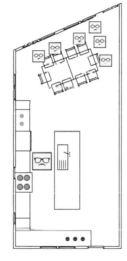
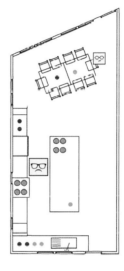

ASSEMBLY LINE

A long, uninterrupted counter works well for those with counter space on either side of the island to hold the range and sink. When not in use, consider placing an interesting vessel on top of the counter and filling it with citrus for a pop of color in the otherwise monochromatic room. A large glass platter filled with clementines or Meyer lemons offers maximum impact.

WATERING HOLE

For those with less space or who lack an arching culinary faucet, siting the sink in the island can give the structure an interesting, sculptural quality. Placement is key. Measure the expanse of the counter and then add a foot to the left or right (whichever frames the range and doesn't intersect visually with cabinet hardware) of center. This slightly offset placement will keep the eye moving around the fixtures in the room and introduces a *wabi-sabi* element that makes for a great conversation starter.

COOKTOP

For particularly adventurous chefs, an under-mount range is a perfect way to show off an exceptionally expensive appliance. Consider how frequently you cook before choosing a corner in which to install the range. If you make more than two meals a week at home, be sure to give yourself at least six inches from the edge of the island to prevent passersby from knocking over boiling pots and suffering burns. Otherwise, the range can be placed at the very edge to give a sense of rhythm to the island.

PRACTICAL CONSIDERATION

The number of appliances should be inversely proportionate to the number of dinner guests. Plan parties accordingly.

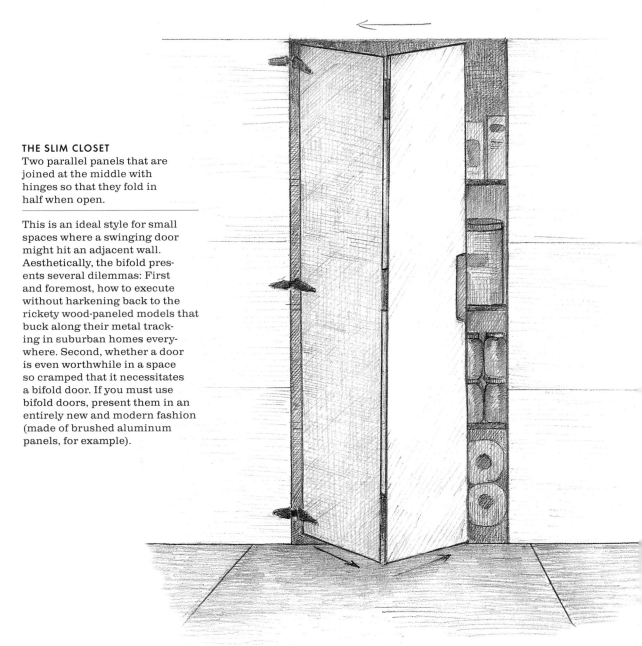

THE SLIM CLOSET
Two parallel panels that are
joined at the middle with
hinges so that they fold in
half when open.

This is an ideal style for small
spaces where a swinging door
might hit an adjacent wall.
Aesthetically, the bifold pres-
ents several dilemmas: First
and foremost, how to execute
without harkening back to the
rickety wood-paneled models that
buck along their metal track-
ing in suburban homes every-
where. Second, whether a door
is even worthwhile in a space
so cramped that it necessitates
a bifold door. If you must use
bifold doors, present them in an
entirely new and modern fashion
(made of brushed aluminum
panels, for example).

Out of the Closet

Pantries are indisputably passé, even to modern homesteaders who make a great show of
stocking their refrigerators and cabinets with exotic foodstuffs. However, there are some
instances when the paltry open shelving above your stainless-steel counters proves inad-
equate. If you find yourself tucking things into the under-counter cabinets (to the point of
an avalanche upon opening) we can allow two kinds of closets: slim and walk-in.

THE WALK-IN CLOSET
A single panel that slides open, retracting into a built-in compartment in the wall.

Pocket doors were popular with Victorians, who liked to keep their rooms as compartmentalized as their emotions. A pocket easily closes off a closet without detracting from the interior architecture elsewhere in the kitchen. It is imperative that the interior of the closet be expertly designed, otherwise the opening will act as a portal into what you'd expect to find in another, messier, more mainstream home. Choose open shelving and specific foodstuffs (green glass bottles of sparkling water are good; diet drinks and cheese crackers are bad) that contribute to the overall aesthetic, if not your stomach.

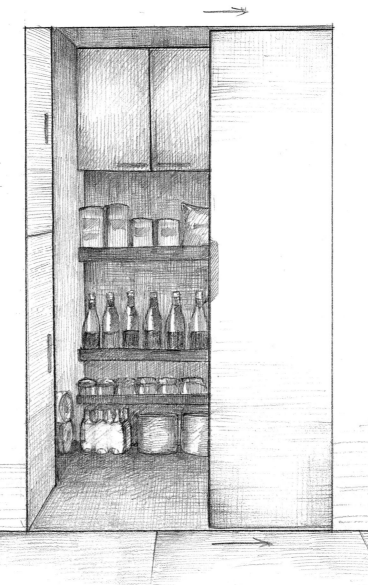

Architecture should speak of its time and place, but yearn for timelessness.

FRANK GEHRY (1929–)

The first "starchitect," Gehry was born to Jewish Polish immigrants in Canada. He changed his last name from Goldberg at the behest of his first wife. Now closely associated with his adopted hometown of Los Angeles, Gehry's deconstructivist style has been criticized by many for existing as "functionless forms" (see Louis Sullivan, page 12) and generally having poor structural integrity. Famously, he designed a building by crumpling a piece of paper and calling it an architectural model in the documentary about his life and work directed by Sydney Pollack.

◉ Notable Works: Cross Check armchair. Guggenheim Museum, Bilbao. Wiggle side chair.

Fork It Over

Danish is de rigueur in the kitchen, the bath, and (in a perfect world) the bedroom. Stelton, Danish manufacturer of carafes, lighting, and serving sets, offers several flatware collections that marry the hard edge of stainless steel with the soft inefficacy of a spork. Here are three excellent choices.

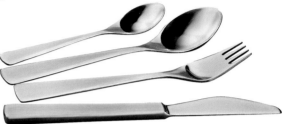

MAYA (1962)

Pleasing rounded edges with stumpy tines. More important, it is part of the permanent collection of the Museum of Modern Art in New York City.

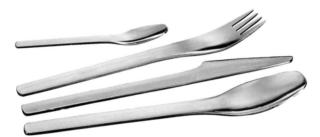

EM (1995)

Satin-polished steel set that was designed by Erik Magnussen, who studied at the Danish School of Arts and Crafts. The spoon is deceptively shallow, surely the designer's comment on the human condition.

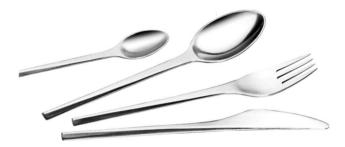

PRISME (1960)

A joint effort from silversmith Jørgen Dahlerup and designer Gert Holbeck. Chopstick-thin shafts give this set a delicious lightness in the hand.

Hot Plates

Such distinctive cutlery demands quiet china. We've chosen three collections that best balance their rigidity of form with the messy colors and textures of plated food. Unlike generic dinnerware from big-box stores, these unique plates and bowls require a financial commitment; a single Heath mug and saucer is $30. If you'd rather divert your savings to a six-burner range or a collection of obscure Austrian wine varietals, we've included an affordable four-piece melamine (plastic) setting. At an incredibly reasonable $60, it's easy to invest in service for eight for less than $500 (but not necessarily advisable).

Massimo Vignelli's streamlined **HELLER** collection

Made of melamine, it's simple, lightweight, and designed to stack tightly together. A boon for those with storage issues. Bonus points for sighing and complaining how difficult it is to obtain the original Italian-made pieces from the mid-1960s, before American company Heller began to manufacture the line.

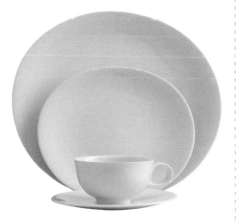

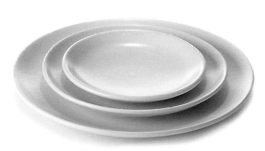

Eva Zeisel's subtle **GRANIT** collection

Smooth white ceramic by the famous centenarian ceramicist. Bonus points for gently reminding guests that although the line of dishes was designed in the 1980s, it wasn't manufactured until 2009 due to Zeisel's exacting perfectionism.

Edith Heath's vaguely organic **COUPE** line

Designed in 1948 by the woman behind Heath Ceramics, the Coupe collection has been in constant production since it was introduced. Bonus points for trekking out to the factory in Sausalito, California, to see the pieces fired and glazed in person.

BATH

Of all the spaces in the home, the bath is the most intimate. Squatting, scrubbing, brushing, soaping—bathroom ablutions are primal at best. Choose clean tile, concrete, and porcelain to help obscure the fact that here we perform our most human functions. Toilets rarely strike an attractive silhouette and, unless properly executed, the necessary lines and fittings that bring water to the room can turn an attractive minimalist space into a cluttered den of porcelain and galvanized pipes.

Symmetry in the bathroom is essential, as it is throughout the home, but the size difference among the sink, shower, toilet, and tub can create design dilemmas. Focus on balance, scale, and insurmountable design challenges (such as a fully lined concrete shower cell with a central drain positioned in a corner of the room, not the center, without a graded floor) that are sure to send contractors into an apoplectic frenzy. And never forget the simple beauty conveyed by a crisp white towel artfully slung over the (rarely used) tub.

The Bath Checklist

Here are the essentials of a modern bathroom.

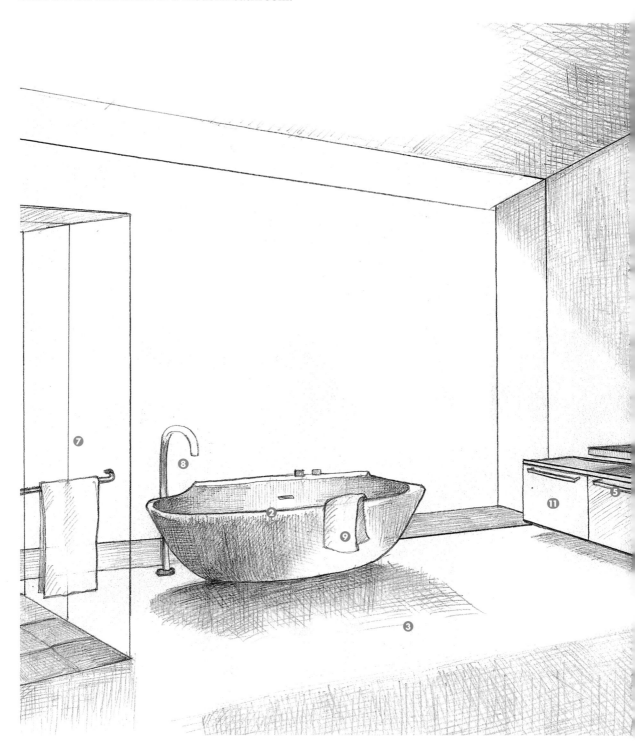

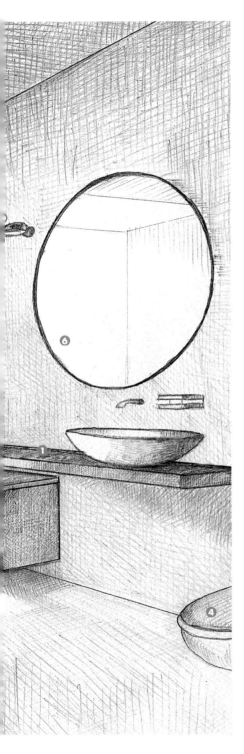

1. VANITY
Aim for clean lines, hard edges, and nothing on the counters. If a double-sink vanity is mandatory, opt for square sinks with aggressive faucetry.

2. BATHTUB
Unless you are assured a Philippe Starck tub, forgo the vessel completely.

3. FLOORING
Present a poured concrete floor (see Beauty Underfoot, page 21).

4. TOILET/BIDET
Power, porcelain, performance: These are the guiding principles for choosing the ultimate seat. Toilets can cost thousands of dollars; allocate funds accordingly.

5. HARDWARE
Choose industrial full-width drawer pulls of the variety used for mechanic's tool chests; German manufacturer Häfele makes an astronomically overpriced version.

6. MIRRORS
Eschew frames in favor of seamless edges. Alternately, eliminate mirrors entirely.

7. SHOWER
Tile, concrete, more tile, and stainless steel. Don't bother with curtains or glass doors; part of modern living is accepting that you are as much a design element as the rest of the accessories in the home, and bath time is no exception.

8. FAUCETRY
For a shower, water tiles are effective and unobtrusive. However, if a wall-less stall is in order, opt for a prison-style nozzle that juts from the ceiling with deliberate hostility.

9. LINENS
Aside from a crisp white towel draped over the tub, the bathroom is no place for any plush textiles. Forget bath mats, washcloths, and curtains of any sort. If you cling to the notion of a conventional bath mat, opt for a sheet of woven bamboo.

10. LIGHTING
Recessed lights work best in such a minimalist space. Vanity lighting can be worked around a custom mirror design so that the bulbs are as unobtrusive as possible.

11. STORAGE
Medicine cabinets need to be built into the wall, else they command too much attention. Towels, toilet paper, and cotton swabs should be hidden in the most discreet corner cabinet.

Royal Flush

The "porcelain throne," the "can," or the "john"—it doesn't matter what you call it. What matters is that you choose something other than the ubiquitous high-back, gush-flushing toilet. In recent years, high-minded designers have taken the utilitarian toilet to new heights. Italian industrial designer Alberto Del Biondi's toilet and bidet series Nerocarbonio, made entirely from carbon fiber (being brittle, perhaps not the best material for such a utilitarian piece), comes to mind as a device whereby form finally trumps function. Scientific advancements include toilets coated with caustic chemicals that obviate the need for cleansing scrubs, retractable plastic wands that shoot out to freshen your most private parts, and remote-controlled heated seats. Here we've selected two revolutionary spa-quality models that also skirt pesky environmental gallons-per-flush regulations, for voiding your bladder and bowels in style.

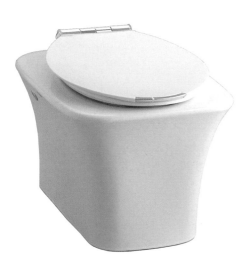

STARCK FOR DURAVIT

Parisian designer Philippe Starck has pimped his über-moderne style for everything from acrylic furniture to watches to yachts. Naturally, bath accoutrements weren't far behind. His SensoWash Starck toilet for Duravit isn't particularly imaginative—just a basic pot. However, he's taken the built-in bidet one step further with settings that are disturbingly self-explanatory: "Ladywash" (a gentle sweep for the gentler sex), "Rearwash" (when a wipe won't suffice), and "Comfortwash" (a moving jet that might just double as a personal massage). After a customized shower down below, a jet dries with warm air.

KOHLER FOUNTAINHEAD

This model from American manufacturer Kohler features a mechanized lid (and ring—industry code for the seat) that lifts and lowers. However, the Fountainhead requires the user to touch a panel to activate the device. It also offers a unique tool for the more health-conscious among us: The bowl is illuminated by what Kohler calls "integrated lighting" for inspecting eliminations. It's an experience designed with the individual in mind—overall, a clever play on the Ayn Rand novel of the same name.

CASE STUDY #2

"Modern offspring are expected to function independently from birth—bath time is no exception."

We have to replace beauty, which is a cultural concept, with goodness, which is a humanist concept.

PHILIPPE STARCK (1949–)

The most famous contemporary product designer, this Frenchman has merchandised himself to the hilt, putting his name on everything from motorbikes to toothbrushes. A partnership with Italian furniture maker Kartell has produced his most well-known pieces. He lives in four different cities (traveling from one to the next on private jets), is onto his fourth wife, and has four children by three different women: two sons, two daughters. He claims to have chosen his children's names (Ara, Lago, Oa, and K) at random using a computer program.

❂ **Notable Works: Louis Ghost Chair. Bubble Club chair. Musée Baccarat, Paris.**

Accessory after the Bath

If concrete floors and walls aren't possible, the next best option is to choose shiny white subway tile. While the rectangular shape necessitates that the tiles are laid horizontally (don't fall prey to the current trend for laying vertically) you can add personality and interest by customizing the grout width.

ONE-EIGHTH INCH
Works best in homes in coastal, liberal-minded communities with independent health-food stores and yoga studios. We've found that the wide expanse of grout isn't prone to mold because these types of homeowners rarely bathe.

ONE-SIXTEENTH INCH
Renovated industrial spaces often need to be retrofitted to include shower areas. Use a standard grout width of one-sixteenth inch to highlight the anachronistic placement of a new bath in an old warehouse.

LESS THAN ONE-SIXTIETH INCH
Opt for minimal grout, with tiles nearly laid edge to edge, if you live in a high-rise apartment or one of those temporary live/work spaces that city planners plunk down in "emerging" neighborhoods. These types of buildings are invariably stuffy due to shoddy HVAC systems, which can lead to toxic mold.

PRACTICAL CONSIDERATION

Maintaining a modern bath means avoiding displaying or even owning items that overtly hint at our base animal instincts. We suggest clean white plastic toothbrushes without any labels or extraneous bristles, Marvis toothpaste in a shiny silver tube, glass water carafes, and the clean graphics of Dr. Bronner's castile soaps.

⊗ ITEMS TO AVOID

Kleenex
Colored towels
Embroidered towels
Patterned towels
Garbage bin
Wicker baskets
Scale
Toothbrush holder
Floral shower curtain
Geometric shower curtain
Linen shower curtain
Curtains of any kind
Toilet bowl brush
Soap dispenser
Bath mat
Laundry bin
Cosmetics
Night-light
Mouthwash
Washcloths
Female hygiene products

Clock
Bathrobe/slippers
Toilet paper
Blow-dryer
Air freshener
Mirrored jewelry tray
Hairbrush
Personal photographs
Loofah
Sink skirt
Magazines
Prescription medications
Plush toilet lid cover and
 matching mat
Kleenex box cover
Decorative shower rings
Glass urn filled with bath beads
Oriental rug
Radio
Electric shaver
Scented candles
Ashtray

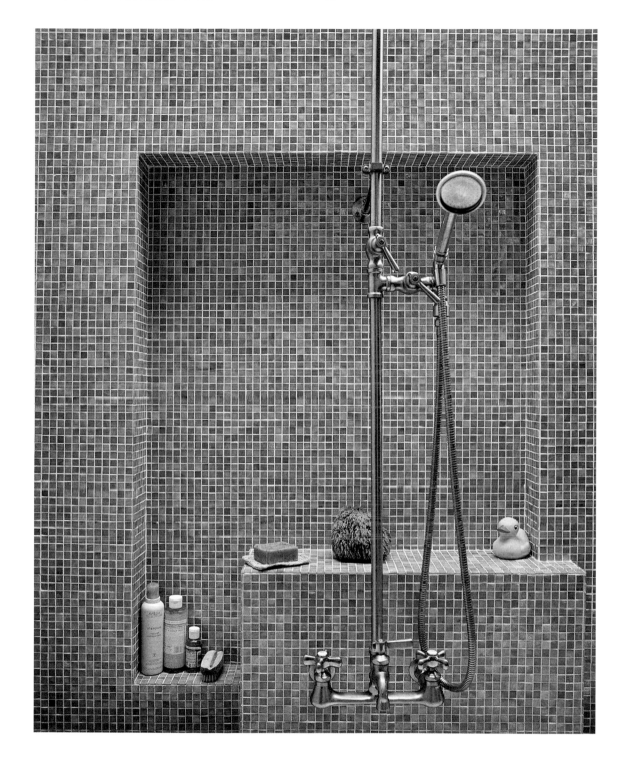

CASE STUDY #84

"The ducky backed into the corner, terrified of the nude gyrations that were about to take place."

CASE GOODS

The great burden of the First World: our predilection for and attachment to "stuff." Alas, there is no room for knickknacks in the modern home. A modern house relies on the form, color, and textures of the surface materials you've so carefully selected to create a striking tableau. Your goal should be extreme simplification. To reach true minimalism, you can expect to purge 80 to 90 percent of your personal belongings, including family photos, heirlooms, and other cherished ephemera.

Navigating the path from maximalist mediocrity to modernity can be traumatic, but it's necessary; don't be discouraged if you can't reach total minimalism on your first attempt. Like an infant learning to walk, voluntarily abdicating all possessions is a process that will be fraught with stumbles. But you must persevere and edit down your belongings to the bare minimum.

Then, to store essential items, such as underclothes and design tomes, a true modernist chooses custom plywood and knotty pine cabinetry for case goods. If you must have freestanding pieces we suggest designs by Eames, Aalto, and Starck. Or choose a midcentury teak credenza that you can tell friends you discovered at a rummage sale. (No matter that you paid a princely sum for it at 1stDibs.com.) Read on to learn more about the best case goods, a few solutions for getting started, and tips on displaying the items that survive the ruthless purge.

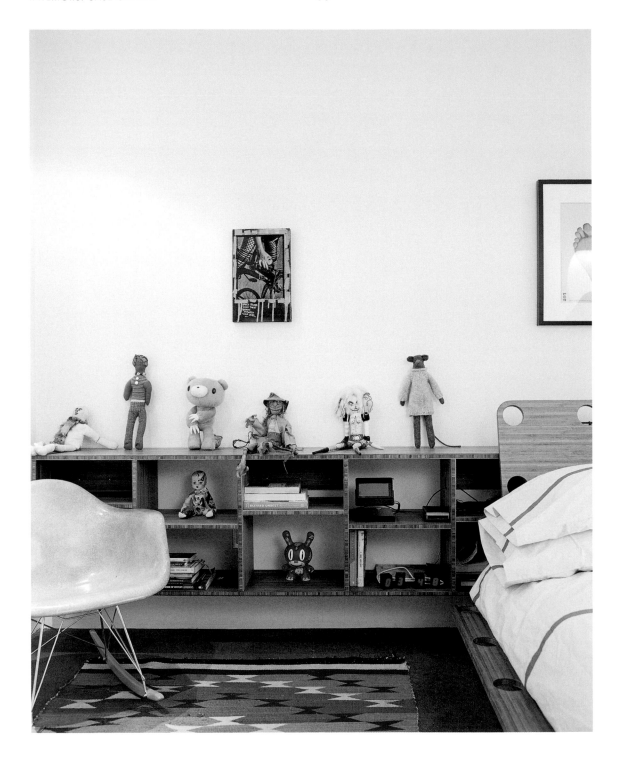

CASE STUDY #226

"No matter how she rearranged them, each remained a
coconspirator in her coital humiliation."

Treasured Chests

Built-ins are preferable, but if that's not possible we recommend choosing from these freestanding designer pieces, which we've easily sorted by structure and the type of abode in which they would be appropriate. Understand, however, that only one of each should be chosen (do not mix and match) and you should have only one storage item per room, with a maximum of three in a household.

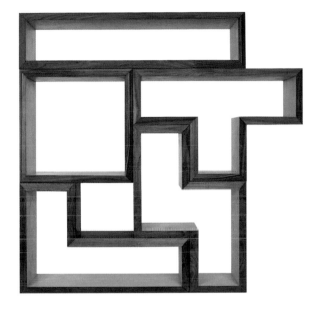

TETRAD MEGA shelf by Brave Space Design

Husband-and-wife team Sam Kragiel and Nikki Frazier took their cues from the granddaddy of arcade games, Tetris, when designing this modular shelving unit. Made in Brooklyn using FSC-certified wood and water-based adhesives, its pedigree could not be more perfect.

◉Best For: Downtown Loft

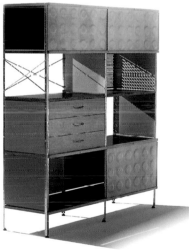

CHESTS by George Nelson for Herman Miller

In an empty bedroom, these top-heavy drawers from the famed American modernist George Nelson (best known for the Nelson clock) make a sculptural statement. Used in an overly furnished interior, however, they may read as 1960s sitcom.

◉ Best For: Midcentury Bungalow

EAMES STORAGE UNITS by Herman Miller

Husband-and-wife team Charles and Ray Eames's masterpiece multifunctional design, this circa-1950 storage system comes in multiple configurations featuring punches of red, blue, black, and white—allow the pieces to be the only pops of color for a restrained palette. The panels and cross-supports are steel with plywood drawer fronts.

◉Best For: Single Family Manse

I want to make sure we live in a world which is super fantastic. I like the material to decide for itself what it wants to be. The material knows better how it can look beautiful.

MARCEL WANDERS (1963–)

The man who's made a point of pairing his open-collar shirts with a string of pearls has made his mark as an over-the-top furniture and product designer and head of Dutch design groups Droog and Moooi. At the end of his CV on his website, he lists a series of Anthony Robbins seminars he attended and the name of his personal trainer under "Additional Education." Infamously, his girlfriend, choreographer Nanine Linning, swung upside down from a chandelier, naked, mixing vodka drinks at the Milan Furniture Fair.

◉ Notable Works: Knotted chair. Horse lamp. Egg vase.

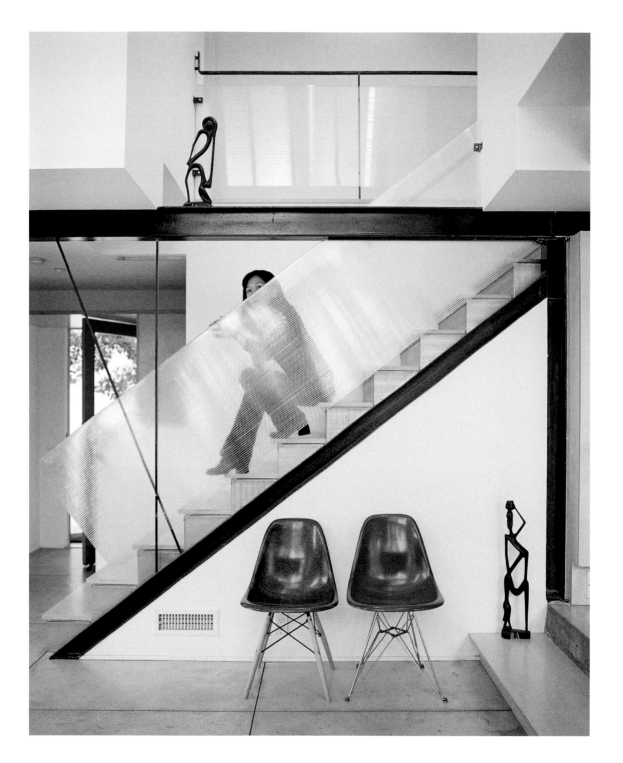

CASE STUDY #167

"The gossipy chairs could sense that there was an eavesdropper afoot."

SEATING

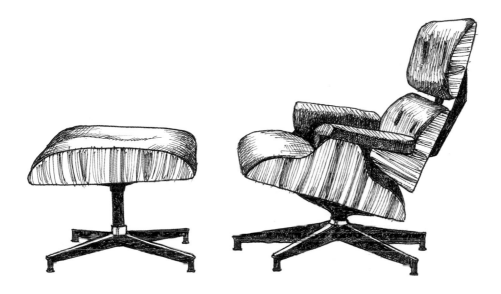

Ludwig Mies van der Rohe once famously said that a chair was harder to design than a skyscraper. We respectfully disagree; *purchasing* the right chair is harder than designing a skyscraper. Aside from surface materials and rooflines, there is nothing more important to the integrity of a modern structure than the seating contained within. No other item in the household defines its owners as much as the chair. Would a Tulip chair person cohabitate with a Louis Ghost chair person? (Would a vegan wear a fur coat? Should anyone outside of an L.L. Bean catalog own a golden retriever?)

 Unlike accessories and case goods, a modern home can never have too many chairs—as long as they're made by the right designers. Granted, most chairs in a truly modern home aren't used for sitting. Instead, they're displayed as sculpture. Winning arrangements include the obligatory spartan seat placed in the corner of the bedroom, perpendicular to the bed. A cluster of small, unyielding chairs in the living areas should appear to enjoy their own company. Dining rooms either display an array of painstakingly mismatched vintage finds or a solid row of clean-lined designs from top European manufacturers, such as Cappellini or Kristalia. Cushy, upholstered furniture—other than Eero Saarinen's Womb chair—should be used sparingly, if at all.

Cheat Seat

When it comes to the four-legged, S-curved, and zigzagged form, we've developed an easy-to-use chart that not only allows you to dialogue about famous furniture designers like a pro, but to find your perfect seat. After an exhaustive poll in which we surveyed hundreds, we bring you the most thorough and reliable guide to choosing the right chair.

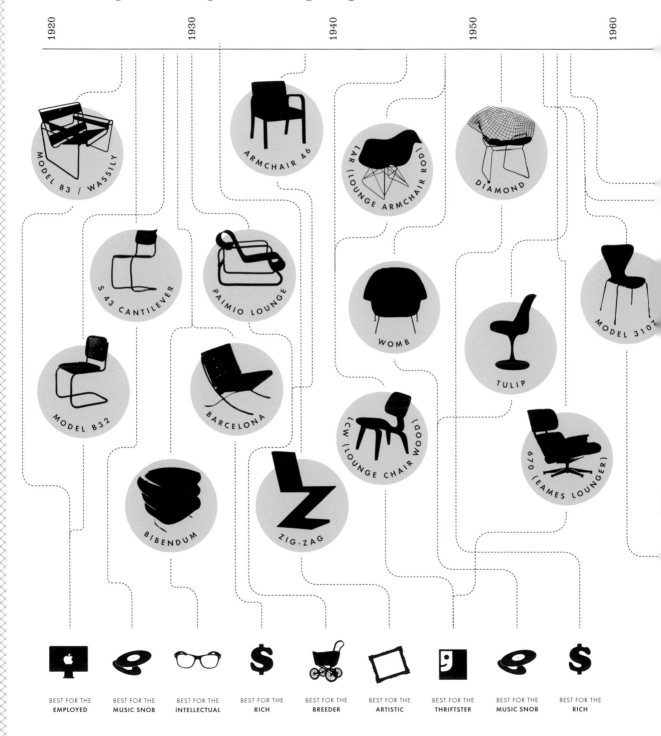

1920	1930	1940	1950	1960

MODEL B3 / WASSILY

ARMCHAIR 46

LAR (LOUNGE ARMCHAIR ROD)

DIAMOND

S 43 CANTILEVER

PAIMIO LOUNGE

WOMB

MODEL 3107

MODEL B32

BARCELONA

TULIP

LCW (LOUNGE CHAIR WOOD)

670 (EAMES LOUNGER)

BIBENDUM

ZIG-ZAG

BEST FOR THE EMPLOYED	BEST FOR THE MUSIC SNOB	BEST FOR THE INTELLECTUAL	BEST FOR THE RICH	BEST FOR THE BREEDER	BEST FOR THE ARTISTIC	BEST FOR THE THRIFTSTER	BEST FOR THE MUSIC SNOB	BEST FOR THE RICH

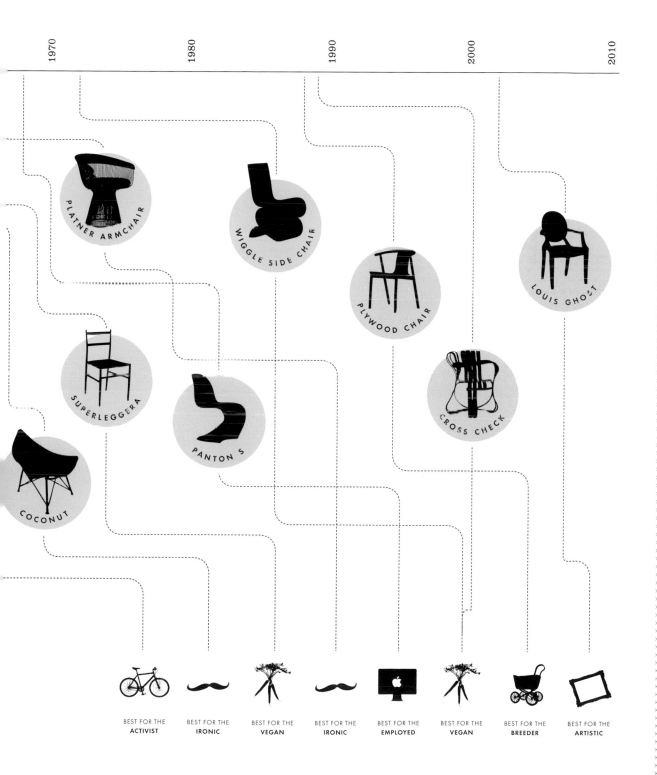

1970

1980

1990

2000

2010

PLATNER ARMCHAIR

WIGGLE SIDE CHAIR

LOUIS GHOST

PLYWOOD CHAIR

SUPERLEGGERA

CROSS CHECK

PANTON S

COCONUT

BEST FOR THE
ACTIVIST

BEST FOR THE
IRONIC

BEST FOR THE
VEGAN

BEST FOR THE
IRONIC

BEST FOR THE
EMPLOYED

BEST FOR THE
VEGAN

BEST FOR THE
BREEDER

BEST FOR THE
ARTISTIC

Always design a thing by considering it in its next larger context—a chair in a room, a room in a house, a house in an environment, an environment in a city plan.

EERO SAARINEN (1910–1961)

Born on the same day as his father, Finnish architect Eliel Saarinen, Eero immigrated to the United States with his family when he was thirteen. He worked for his father and then for himself, designing many prominent public and private residences. Friends with Charles and Ray Eames and Florence Knoll, Saarinen was part of the modernist design Rat Pack of the 1950s. He divorced sculptor Lilian Swann in 1953 and named his son with his second wife, *New York Times* art critic Aline Louchhem, Eames.

◐ Notable Works: Tulip chair. St. Louis Gateway Arch. Womb chair.

Sitting Pretty

Once you've chosen the right chair, use these floorplans to orient the seat correctly.

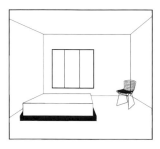

BEDROOM
In the bedroom, the chair should be positioned in a far corner, facing the bed.

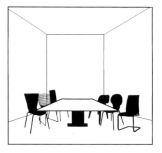

DINING ROOM ONE
For an eclectic look, arrange a collection of vintage seats around the dining table.

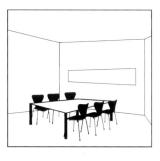

DINING ROOM TWO
For a severe and unmarred aesthetic, line angular chairs along each side of the dining table, with none at the heads.

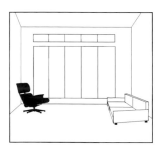

LIVING ROOM ONE
An Eames lounge chair should be alone, facing the sofa.

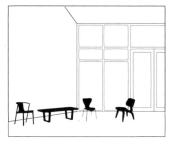

LIVING ROOM TWO
No more than three chairs should be clustered around a small side table, with a low bench—preferably the Nelson platform bench—serving as a sort of table.

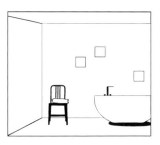

BATHROOM
Choose a steel seat for the bath and use it to hold a single folded towel.

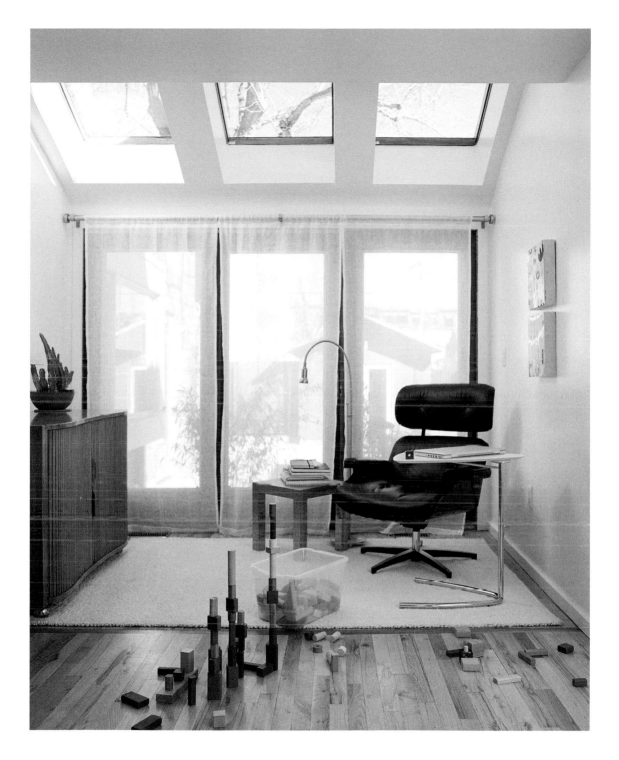

CASE STUDY #989

"Stationary as it was, the Eames lounger appreciated the blocks' sense of industry."

COLOR

Nothing says more about a home and its owner than the hues chosen throughout the house. Color can set a mood, camouflage architectural flaws, and—depending on your belief system— bring auspicious blessings to your bedroom and your bank account. Color also delineates genius from gauche. Consider and shudder at the horror, for example, of how Ludwig Mies van der Rohe's iconic glass-walled Farnsworth House would have looked executed in Floridian teal instead of pure white. Or a Mondrian painting in pale pastels. These artists knew that as impressive as their creations might be in a sketch, the finished product elicits a visceral response from admirers—on a physical and emotional level—only if it is realized in the most compelling colors.

The modern home is no different than those great modernist masterpieces. Your collection of designer furniture, quirky art, and rare first editions will fall flat if displayed against a dusty rose wall or a navy blue ceiling. A wonderfully bleak bedroom will cause nightmares if the mattress is covered with a cherry-red quilt. Unfortunately, an inferior palette can destroy even the best-laid design plans. Therefore, it's essential to learn how colors relate to one another, how designers measure and qualify different shades, and to understand the difference between Pantone spot and process colors.

Color Theory

Before you can make an informed decision about the paint palette for your home, it's important to educate yourself about how color is measured and identified. Then you can expertly choose the correct shade of white for walls and ceilings.

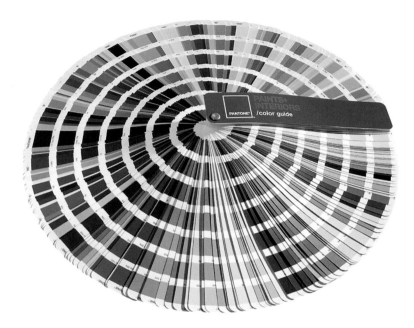

PANTONE COLOR MATCHING

Standardized color matching system that allows reproduction of exact shades. Using the Pantone system, individuals and manufacturers can make sure that colors will match without having to compare hues in person. Many states and countries use the Pantone system to measure and regulate the colors of their flags; it's worth investing in a guide if only to display prominently on your desk.

NATURAL COLOUR SYSTEM (NCS)

This process for evaluating hues was first presented by the Swedish Colour Center in 1969. It measures color by evaluating the amount of black, saturation of color, and a percentage value between two of the opponent-process colors—red, yellow, green, or blue. Given its Scandinavian origins, this is the preferred system.

MUNSELL COLOR SYSTEM

Developed by Professor Albert H. Munsell in the 1900s, this system evaluates colors on three dimensions: hue, value (lightness), and color purity. Colors are identified by three numbers that relate to the three dimensions.

PRACTICAL CONSIDERATION

To impress your friends and colleagues, purchase the software that converts the three different systems.

White Out

We've culled from the thousands of shades and combinations of commercial paints to create the ultimate palette for a modern interior—whites that turn blue, especially in shadow. Bring this swatch sheet to your paint purveyor for an exact match.

EGGSHELL	SOFT WHITE	CONGEALED CUSTARD
PEARLESCENT	KNIGHT WHITE	CRISP LINEN
MR. WHISPERS	DOVE	PURE PUTTY

PREFERRED BRANDS

Although, once on the walls, no one may be able to tell the difference, it's essential that you choose expensive, superior paint brands over the hardware store varieties. Low-VOC and eco-friendly lines garner even more congratulatory attention.

We suggest the following makers:

- Donald Kaufman Color
- Pantone with Fine Paints of Europe
- Farrow & Ball
- Mythic

As we begin principally with the material, color itself, and its action and interaction as registered in our minds, we practice first and mainly a study of ourselves.

JOSEF ALBERS (1888–1976)

A student and professor at the Bauhaus, Albers dabbled in furniture and glass design before moving to the United States with his wife, fellow Bauhaus student Anni, when the Nazis shut down the German institute. He ran the painting program at the famed Black Mountain College in North Carolina, where he taught everyone from Cy Twombly to Robert Rauschenberg. A color theorist and abstract painter, he rarely socialized and lived a monastic sort of life.

❷ Notable Works: *Interaction of Color* (book).

Fantastic Four

White is the only choice for expansive walls and ceilings, as it complements angular architecture and adds gravitas to a prefab structure. However, certain areas may benefit from a bold shock of color. A powder room, for example, is enlivened by a vivid pink wall. The juvenile appearance of a child's bedroom, on the other hand, can be tempered by somber black. In order to keep the interior palette restrained and sophisticated, use CMYK as your guide. Long employed by print designers, this four-color subtractive system works so well with modern interiors because each color (C: cyan, M: magenta, Y: yellow, K: black) subtracts brightness from white.

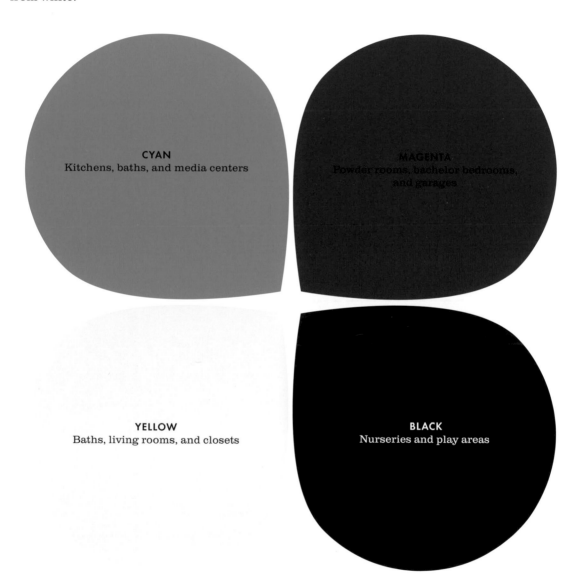

CYAN
Kitchens, baths, and media centers

MAGENTA
Powder rooms, bachelor bedrooms,
and garages

YELLOW
Baths, living rooms, and closets

BLACK
Nurseries and play areas

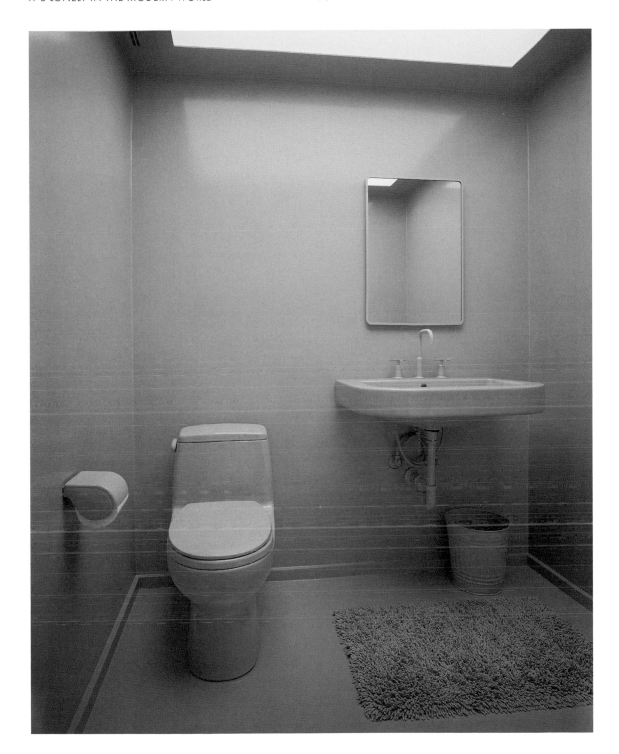

CASE STUDY #7213

"The only thing more disturbing than his plaintive wails
during their one-night stand: stumbling into the bathroom
in the morning."

LOFTS

There is nothing more emblematic of modern life than the loft. Simply put, lofts offer a delicious juxtaposition of old and new that is almost impossible to achieve in a single-family home. A genuine loft derives its eclecticism and tranquility from its patina. Exposed beams and concrete floors bear the unique imprint of their previous incarnations. Each paint splatter is to be cherished, each exposed beam celebrated, but none is more charming than the marks and scratches from heavy machinery that was dragged long ago by underpaid factory workers. These are the details commonly overlooked by developers who plan new-construction "loft-style" condominiums.

A loft is more than an open-plan living space; it's a living organism that breathes the past and embraces the future. It takes an adventurous spirit to move into an emerging neighborhood and set up camp in an abandoned concrete building. Where lofts feature exposed ductwork out of necessity (who cares about low-hanging ductwork with all that ceiling height?), the architects behind most of today's single-family homes tend to hide ductwork systems from sight, inside of walls or ceilings. So if the reality of loft living isn't as appealing as the dispassionate ideal, then simply install faux ductwork—all the cool with none of the compromise. We'll show you how.

Steely Eyed

Authentic lofts were once only available to artists willing to brave "colorful" neighborhoods for the benefit of generous square footage. But now, you too can enjoy the pleasures of loft-style living by installing exposed ductwork in your home. Yes, these exposed air ducts will rattle and shake the room. Yes, they will leak. And no, they may not make sense with the architecture of your home. But the cache of ductwork far outweighs the minuses.

Here we've selected the most compelling steel striations and configurations for that genuine loft look. Choose a shape that corresponds with your decor; the ductwork should command attention, but not at the expense of your furnishings.

STRIATIONS

BRUSHED STEEL

GALVANIZED STEEL

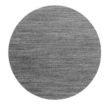

WEATHERED STEEL

POLISHED STEEL

CONFIGURATIONS

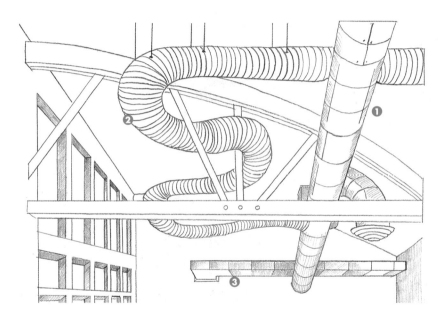

1. THE ORIGINAL
Rounded with a
slatted vent

2. SPIRAL
Snaking all around
the ceiling

3. GEOMETRIC
Thick rectangular
pieces with
a heavy hood

PRACTICAL CONSIDERATION

Akin to oversize wind socks, fabric air ducts offer more aesthetic interest than their spiral metal counterparts. The only downside: Unlike traditional metal versions, which are frequently faux, fabric ducts must be operational or else they simply dangle from the ceiling like a flaccid appendage.

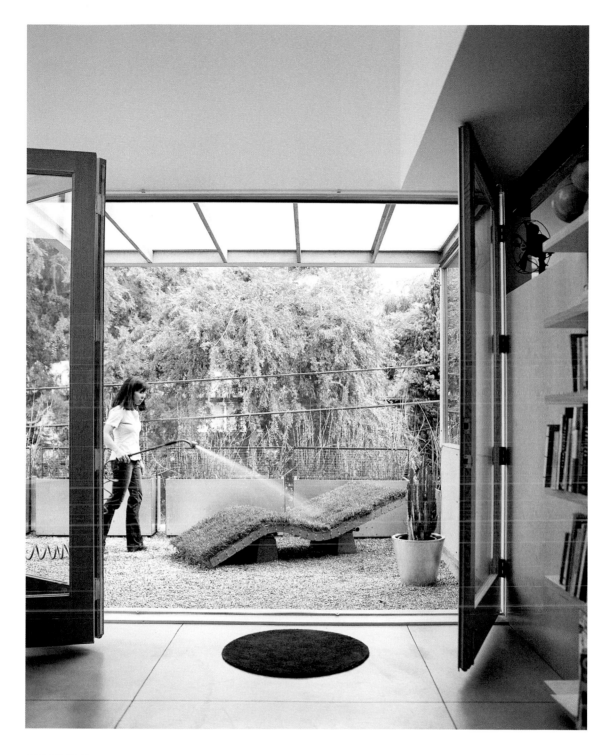

CASE STUDY #4

"Open-plan urban living be damned, she deserved her own
little acre."

Not many architects have the luxury to reject significant things.

REM KOOLHAAS (1944–)

Early in his career, Koolhaas studied to be a screenwriter, even penning scripts for soft-core porn director Russ Meyer. As an architect, he founded the Office for Metropolitan Architecture (OMA) in the Netherlands, which has designed and built massive public and private structures worldwide. A professor at Harvard, he's also designed street toilets and bus stops in Holland.

❯ Notable Works: Serpentine Gallery Pavilion. Prada retail stores. Seattle Central Library.

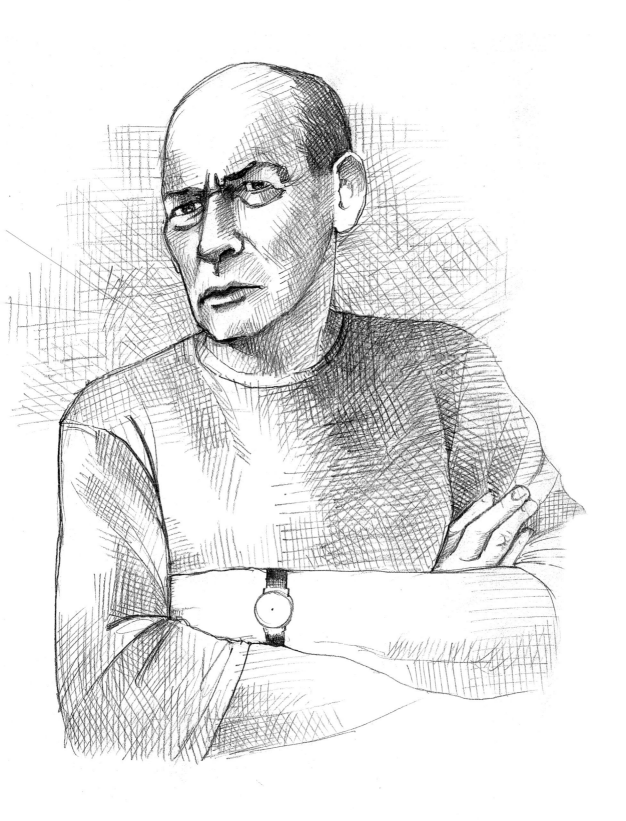

Walled Off

Erecting walls in a loft residence defeats the purpose of the open-plan aesthetic. In an apartment that has little or no definition among living, eating, cooking, or sleeping areas, use a see-through bookshelf (cube shelves are especially modern; see page 57 for choices) to demarcate "rooms" within the loft. Admittedly, there are some instances when you may find yourself itching to throw up a partition or break out a folding screen to shield certain areas or activities from general view. If you're uncomfortable falling asleep while your partner's friends drink microbrews and discuss their unpublished novels on the sofa beside you, choose from the following dividers.

CORAL TRIFECTA SCREEN by
Chris Kabatsi for Arktura

A psychedelic open-weave pattern gives this powder-coated steel divider an edge. The design is laser-cut by this group of young designers from Los Angeles using mathematical algorithms.

DESMOND SCREEN by
Jonathan Adler

This midcentury-looking design from Mr. Happy himself shows off the graphic lines of the walnut cutouts without sacrificing the openness of the room.

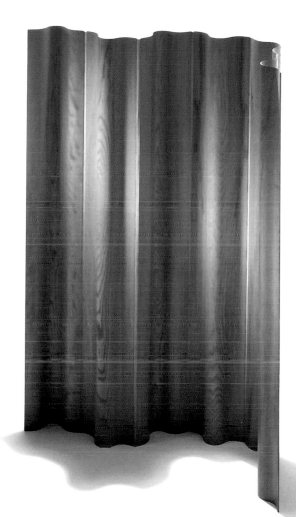

PLYWOOD PARTITION by
Charles and Ray Eames for Herman Miller

A true classic, this undulating wall of plywood offers a generous sixty inches of privacy. It folds up easily for storage.

PRACTICAL CONSIDERATION

In a new loft (that is, a building built to mimic the experience of a reclaimed space), you can create a rich patina on the concrete pilings by purchasing a stain that will offer the appearance of a weathered texture. See page 21 for the most sought-after concrete hues. The stains can also be used to create a mottled surface for concrete floors. If you are able to build up in the unit and create a bedroom on the "second floor" (a loft within a loft, if you will), and must erect walls, be sure to frame said walls with clear Plexiglas to retain the illusion of openness.

SECTION 2: EXTERIORS

Our homes are monuments. But unlike a monument erected to commemorate a great battle or fearless leader, our homes are dedicated to ourselves. So it makes sense that the exterior of a home does much more than protect homeowners from the elements.

The building and its surroundings speak volumes about its inhabitants—from shrubbery and pavers to siding and windows. At the most basic level, you can judge a home by its shape and roofline, by the landscaping that frames it, and the systems that power it. Making the right choices for your exterior is of great importance, in part because of the permanence of these decisions. Indoors, you can easily toss and replace an inferior chair. Not so with roofing or windows or photovoltaic solar electric systems.

Designers and architects often advocate "bringing the outdoors in," a philosophy that relies heavily on the assumption that there is something appealing about the unruliness of nature. More often than not, however, it's the outdoor areas that should be shaped by the design scheme of the interior—bringing the indoors out, if you will.

In this section, we'll guide you through the treacherous process of selecting exterior details that complement both the rooms inside and the larger environs outside. The vast maze of your local garden nursery will become an easy-to-manage resource after reading through our suggestions for plants, pots, and pesticides. Untouched wilderness will give way to a controlled concrete patio filled with geometric outdoor seating, a shiny metal fire pit, and a slick boxed pool. Unsure of how your dedication to the environment fits into all this? We've covered the basics, from alternative lawn care to renewable energy. If you reach a crossroads where the choice seems unclear, we recommend the perennially winning design ethos of unified juxtaposition.

CASE STUDY #390

"Something to do with architectural complexity and contradiction; everything to do with seasonal affective disorder."

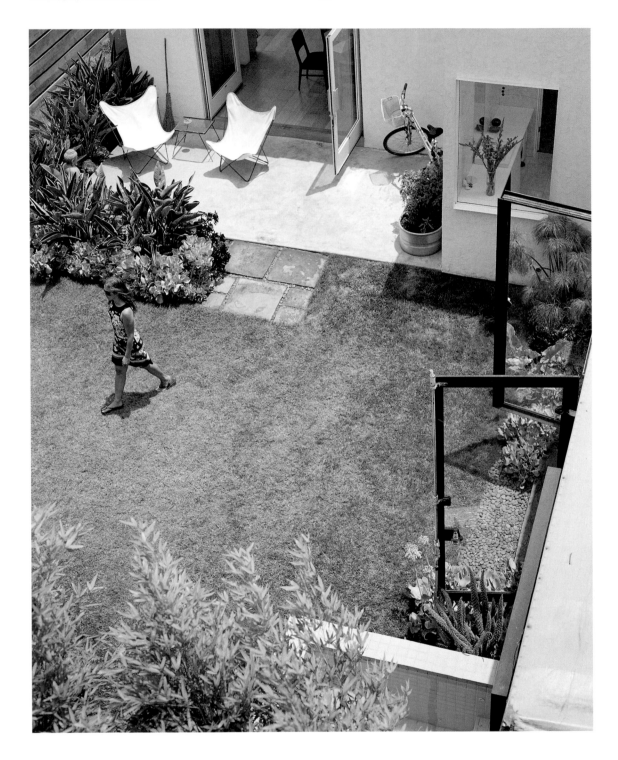

CASE STUDY #55

"She'd perfected the post-breakup stoic stride."

LANDSCAPING

One of the key elements of a successful modern home is how well it harmonizes with the natural world. Thoughtful landscaping will maintain the tension between the built environment and the natural environment. The word to remember here is "balance." For instance, if your exterior is plywood sheeting, then an apron of concrete enclosing the perimeter will create a beautiful balance. A successful landscape balances large, chunky species with their spindly, sticklike counterparts.

To start, take stock of the native plants and existing garden installations. Survey the site and jot down a few notes about the landscape that is and your hopes for the landscape that will be. Then close your eyes and conjure a natural outdoor space. If you imagine a prairie, turn one corner of the yard into a hedge of wispy grasses. If you visualize a verdant rain forest, turn a patch of the yard into an expanse of stone punctuated by stark palms. The process begins by thinking big and then editing your vision down to one or two plantings that hint at the inspiration behind the design.

Natural Selection

Flora is a key element in creating an outdoor tableau. It can be difficult to find just the right species to complement a contemporary structure. Spiky plants work best—agave, cactus, yucca, prickly pear varieties, and the like. Leaves should have ragged, sharp teeth. Trunks should be stoic, hardy, and impenetrable. Birdhouses, rope hammocks, and garden gnomes are discouraged, unless you are well versed in the art of irony. But irony is risky and requires years of study.

CACTI/SUCCULENTS

Sedum

Aloe

Sempervivium

Prickly pear

⊕ **PROS:** Geometric, low maintenance, and hardy with a retro Laurel Canyon vibe.

⊖ **CONS:** Shrivel without loads of sun.

GRASSES

Bastard toadflax

Switchgrass

Showy milkweed

Stinging nettle

⊕ **PROS:** Native grasses mimic the strong lines of modern architecture.

⊖ **CONS:** Havens for deer ticks, ground snakes, and chinch bugs. Can be mistaken for a lawn in need of mowing.

BAMBOO

Clumping bamboo

Running bamboo

⊕ **PROS:** Tall and spindly. Although invasive, seemingly an eco-minded choice.

⊖ **CONS:** Attracts pandas.

PRACTICAL CONSIDERATION

◉ Beware of flowering species, as they rarely convey the necessary gravitas.

◉ Avoid species and cultivars described with terms such as "rosette," "prairie," or "ornamental."

◉ Purchase a splendid pair of Japanese secateurs and display prominently when offering friends a tour of the garden.

◉ You can secretly treat your crops with banned chemical pesticides like DDT to keep garden pests at bay. To avoid suspicion, spray at night and make a great show of watering your plants from a gray-water cistern or rain catchment during the day.

◉ If you have the misfortune of inheriting a landscape full of mature privets, trim the hedges down to cubes no more than two feet high to achieve a grounding effect on these otherwise abhorrent shrubs.

AGAVE

Kichiokan

Agave attenuata

Agave horrida

Durango delight

⊕ **PROS:** Related to genus *Yucca*, which lends itself to affected pronunciation.

⊖ **CONS:** Almost impossible to maintain in cold climates.

I don't divide architecture, landscape, and gardening; to me they are one.

LUIS BARRAGÁN (1902–1988)

Considered the most important Mexican architect of the twentieth century, Barragán studied engineering but was self-taught as an architect. He was born into a wealthy family, but co-opted the saturated paint-washed walls of traditional Mexican country homes for his modern structures, including many skyscrapers that dot Mexico City's skyline. Little is known about his personal life, although it's commonly understood that the immensely private Barragán was very religious and deeply closeted about his homosexuality.

❯ Notable Works: Barragán house. Tlalpan chapel. San Cristóbal Estates.

Throwing Stones

Gravel is an important outdoor element, whether used for ground cover, garden beds, pathways, or lawns. Lest you get irritatingly pleased with yourself over the decision to landscape with rocks, keep in mind that you're not the first to cultivate this schema. These "dry" landscapes have a storied history that begins in Asia. While most associate rock gardens with Japan, Zen Buddhists in China were the first to incorporate petrified minerals into a controlled landscape. However, the most famous remain the *karesansui* in Japan, where stones are arranged to create pleasing patterns and raked into perfect lines with specialized tools.

Today's dry landscapes aren't raked (too predictable, with all those miniature desktop Zen gardens languishing in the waiting rooms of psychiatry offices) but merely scattered. Stone eliminates the need for irrigation, weeding, and other costly maintenance. Approach the process as you would when choosing wall paints: bring home "swatches" (rock samples) to compare and contrast. Consider sheen, surface, and size.

Nothing sets off a modern exterior like a raw surface. The term "scorched earth" originated in the military, where it was used to describe the operational strategy of destroying anything that might be useful to the enemy as you advance into their territory. Although the practice is banned under the Geneva Conventions, there's no law against reclaiming the technique for use at home. Simply obtain a burning permit and raze the premises with fire, backhoe, and small explosives. Maintain the look by spreading silica desiccant gel twice a year.

GRAVEL TYPES

CLASSIC
Crushed limestone works well for wide expanses.

CRYSTALLINE
Quartz with a slightly jagged profile is suitable for small courtyards.

PRACTICAL CONSIDERATION

Enjoying a gravel lawn requires dedication and practice—namely, toughening your feet into little calloused hooves. Begin by exposing your tender toes to the elements in a controlled environment; create a small indoor gravel pit and practice walking, standing, and generally massaging the soles.

CLASSIC LITE
Slightly whiter crushed limestone is best used to edge planting beds.

DOMED
Old-school pebbles are best for walkways, French drains (troughs that redirect groundwater), and patios.

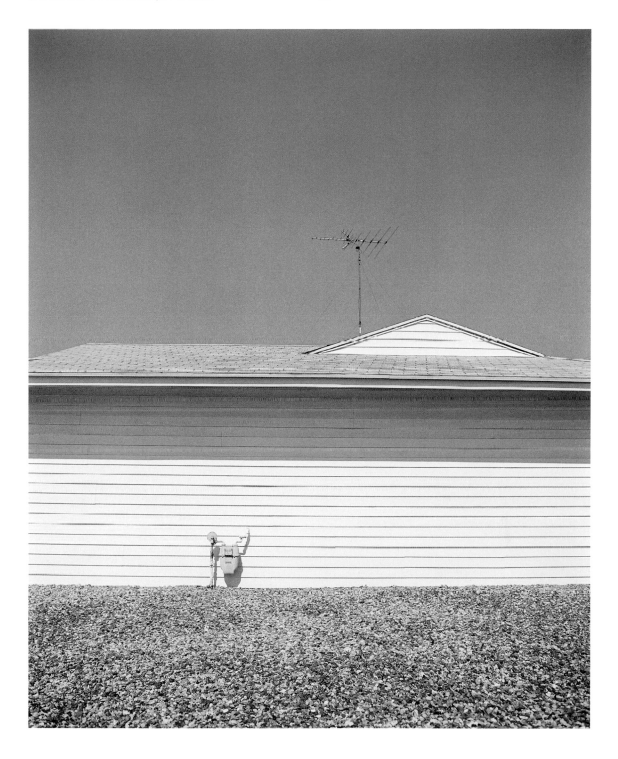

CASE STUDY #0667

"The television antenna quivered with resentment."

ROOFLINES

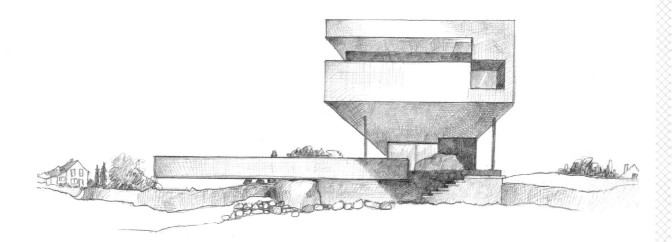

Just as a book is judged by its cover, architecture is judged by its exterior shell. Within that shell, no structural feature is more important than the roofline, which accounts for 80 percent of exterior focal points, beating out cladding, landscaping, and windows. Angles and roofing materials indicate the character, integrity, and mystique of your home, and, by extension, yourself. Even the most rote prefab building takes on new relevance with a perplexingly angular roof.

The material used to shield your home from the elements is just as important as the slope of the roof. There are a baffling number of material choices to consider, along with the roofline's pitch and profile, as well as how the roof will present within the surrounding environs. For instance, slate can read as either painfully old-fashioned or stunningly modern—it all depends on the execution. A green roof requires a flat surface; or does it? And asphalt is relegated to the realm of mediocrity. (That one isn't up for discussion.)

In this secion we'll survey and weigh the pros and cons of a wide range of materials, from seamed metal to organic thatching, along with a dynamic array of rooflines that will help you choose a building profile that balances the solidity of the structure with the depth of your design ethos and the vastness of the sky above.

Up on the Roof

If the home is a living, breathing organism, then the interior rooms would be the nucleus and the framing would be the protective membrane. Just as a cell's shape dictates its movement, purpose, and reactivity, the angle and pitch of your home's roof will determine its place in the architecture continuum. Basic, high-pitched double-gable houses are legion; venture outside the box-within-a-box thinking that is so pervasive in contemporary architecture theory and choose a profile that conveys your individuality and disdain for social norms.

BUTTERFLY

Inverted at the center of the building, the middle sits lower than the top. This roofline is most sought after because it is the exact opposite of a traditional roof with a central peak. In addition, the dip in the midpoint creates dramatic ceilings on the interior, which can be uplit to create an isolating and visually challenging room. The style is nearly synonymous with midcentury houses erected in California communities such as Palm Springs, but has been reclaimed by contemporary designers all over the world. There is a negative roof pitch.

CURVED

An arched roof creates visual interest both indoors and out. For environmental credibility and elemental harmony, match the curve to the gentle undulations of the earth around the surrounding property. Alternatively, a modern home with a curved roof situated on a plateau makes for an unexpected counterpoint to the flat land. The curved roof is rooted in traditional Asian architecture, where it was finished with clay tiles; achieve maximum impact today by executing in white rubber. The roof pitch is almost nonexistent.

FLAT

Historically, flat roofs were only used on sheds and other uninhabitable structures, as they tend to leak and are prone to collecting standing water. Despite the obvious and inherent design challenges (and health concerns), modernist architects have embraced the look whole-heartedly and today most modern homes flaunt a flat roof. Generally, these roofs are only suitable for temperate climates, as the horizontal plane collects snow and debris in regions with harsh winters. Nonetheless, modernist aesthetics trump Mother Nature, and the flat roof can now be found in nearly every climate. There is no roof pitch.

BI-LEVEL

The roof of a bi-level sits on two separate floors. Originated by Frank Lloyd Wright, the lower surface of this design doubles as a perch for observing neighbors without actually descending to the pedestrian sidewalk. It's an excellent alternative for those unable to commit to a flat roof. Bi-levels are best suited to houses that face a busy street, as the elevation is focused on the front with little decorative interest on the rear. The roof pitch is extremely low.

GABLE

It should be noted that the gable roof is included only for reference. The style is to be avoided at all costs. No amount of plywood, concrete, steel, or vintage Knoll furniture can diminish the inherent and depressing conventionality. The roof pitch is pretty extreme.

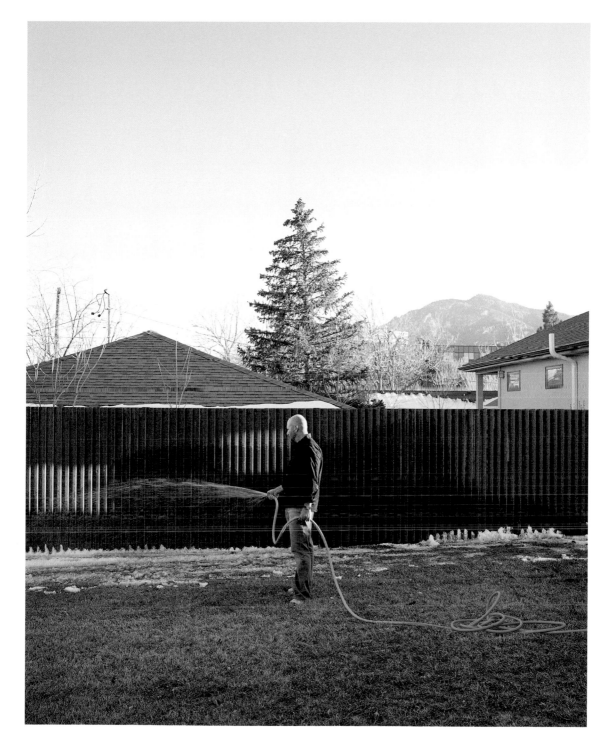

CASE STUDY #71

"Watering the frozen lawn had become his only release from the sameness of his suburban neighbors."

If order and logic are in the architecture, then architecture will inevitably complement nature.

CRAIG ELLWOOD (1922–1992)

A true American hustler, Ellwood was born Jon Nelson Burke. After leaving the army, he and his brother set up a building company called "Craig Ellwood," the name of which they borrowed from a nearby liquor store of the same name. He took a few classes in structural engineering and then opened his own firm. He sold clients on his vision and then got licensed architects in his employ to do the actual design. With his skills for promotion, he managed to fuse the style of Mies van der Rohe with laid-back California bungalows.

❯ Notable Works: Art Center College of Design, Pasadena. South Bay Bank, Los Angeles.

Shingle Style

As we learned in the previous section, a flat roof is ideal. It makes a perfect base for seeding a grassy knoll: the illustrious "green" roof. However, if a flat roof isn't possible, it's imperative that the material used to sheath the roof is in keeping with the overall modern aesthetic of the home and its environs. Many designers advise taking a tour of the neighborhood to determine which roofing material will best fit in with the look of neighboring houses. We suggest taking that same tour, but with a different goal. Once you've compiled a short list of the most common roofing materials, choose something completely different, the polar opposite if possible, to ensure that your house has individuality, delivers visual impact, and reflects your triumphant journey from mediocrity to modernity.

1. SOD

The concept of a green roof may seem modern, but the practice of growing vegetation on top of roofs dates back thousands of years, perhaps even before recorded history. The sod roof of yesteryear was a way to hold together the sheets of bark that composed the inner roof. The sod roof of today is purely decorative.

⊕ **PROS:** Vegetation growing on the roof signifies a certain cultural and environmental awareness and brings with it a delightful self-satisfaction. Plant your green roof with clover, knotweed, and something fragrant, like mint. See pages 88–91 for more recommended species.

⊖ **CONS:** None.

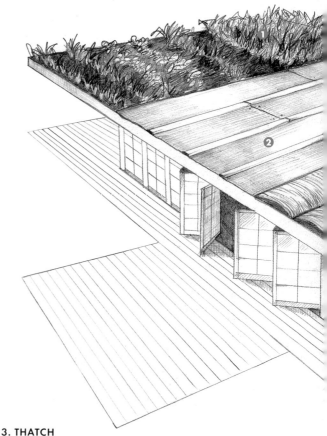

2. METAL

Metal roofs have been around for hundreds of years and feature a wide variety of materials from copper to zinc. Tin tiles became popular in the nineteenth century. However, for your purpose, the only metal roof is standing seam. These are sheets of steel that are punctuated with raised vertical lines. They are manufactured on-site, with each sheet crimped together at the seam to ward off rain, snow, heat, et cetera.

⊕ **PROS:** Extremely durable and gorgeously minimalist, a metal roof can last up to fifty years.

⊖ **CONS:** Provides a steel-drum-style background noise during inclement weather.

3. THATCH

Dry vegetation such as reeds, straw, and heather is thickly layered over an inner roof to protect it from the elements. This is an incredibly old technique, and examples can be found everywhere from sub-Saharan Africa to the United Kingdom, where many pasty pub crawlers with troubled teeth still lay their heads under a thatched roof.

⊕ **PROS:** Unlike contemporary counterparts, a good thatching can last half a century. It hasn't taken off in hip modernist circles; if you're a gambler, installing a thatch roof may make you a trendsetter.

⊖ **CONS:** Unfortunately, the look is incongruent with contemporary architecture and almost guaranteed to raise eyebrows at city building permit offices.

4. ASPHALT

Almost every roof on every single-family home in North America is clad with the ubiquitous asphalt shingle. Made from a base of composite materials (ranging from fiberglass to wood pulp), it is soaked in an asphalt mixture (sticky liquid derived from crude oil) which is embedded with shards of rock.

⊕ **PROS:** None.

⊖ **CONS:** These shingles off-gas something wicked and aren't even close to environmentally friendly. Many companies offer collections that mimic the look of slate or wood shingles, even in a putrid green (meant to mimic what exactly?), but overall asphalt denotes suburbia.

5. CLAY TILE

Rarely seen on houses in the Northeast, clay tiles are most popular in temperate climates, such as California and Florida, where they cover even the most tragic tract homes. The use of clay tiles for roofing goes back twelve thousand years, with most examples employing a long tile with a curved butt that was fitted into another tile to create a tessellated surface. Clay tiles fell from fashion in the nineteenth century, when metal roofs (which were easier to install and maintain) became popular.

⊕ **PROS:** None. Except they're sort of sustainable, or at least recyclable.

⊖ **CONS:** Metal is better, and besides, clay roofs are synonymous with faux Tuscan villas in gated golf course communities.

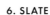

6. SLATE

There is evidence that some settlers in the New World used slate to cover their homes, but quarrying and transporting the material was so costly that the practice wasn't common.

⊕ **PROS:** Noncombustible and lasts up to two hundred years.

⊖ **CONS:** This natural stone is superheavy and expensive, and is more likely to be seen on a Tudor Revival than a contemporary modular home. Also crazy expensive.

CLADDING

Like the skin that covers our bodies, cladding is the largest organ on the living, breathing organism we call home. It protects the structure from the elements. It acts as the gateway from the outdoors to the indoors. And most important, it makes a statement to the world about our personal aesthetic and design credo. It's essential to choose the right cladding. A daring designer flush with a million-dollar budget might find it exciting to wrap a house in the most avant-garde materials—hot-pink rubber, for example, or barbed wire set in stucco. But while high-profile designers can afford to take pleasure in deconstructing the semantics of "shelter" on someone else's dime, you need to sheath your house in something less obtuse than pink rubber and something more complex than cedar shingles.

You don't want to ruin a cantilever profile with predictable materials. Instead, look to unconventional products that appear simple and straightforward to the naked eye but are deceivingly complex. For instance, plywood, standing-seam stainless-steel panels, fiber-cement planks, or panels of aluminum. The goal is to bring attention to the crisp clean corners of your home's architecture, to turn it into a beacon of modernity in a world populated with homes clad in sad vinyl siding.

Facing Facts

A modern home stands apart within the urban milieu as a
pared-down structure. It should derive its character from pro-
portion, without relying on fussy ornament. For best results
we recommend either highly engineered or unexpectedly raw
cladding. Facing should be installed in a horizontal or vertical
orientation; never wrap at the diagonal without the guidance
of a licensed architect. Here we've outlined the types of clad-
ding that work well on a truly modern home.

1. FIBER CEMENT

Fiber cement siding is made
from cellulose, cement, and sand.
It's manufactured in sheets,
which means that little material
is wasted. It's durable, will last
indefinitely, and is nearly impervi-
ous to the elements, including
fire, termites, and tornadoes.
It comes in a rainbow of hues.
When laid vertically in strips it's
a slick answer to dated shingled
vernacular; laid in panels, it's a
refreshingly deconstructed riff
on siding. Unfortunately, the
most prominent manufacturer,
James Hardie, is still living down
an asbestos scandal in Australia,
where the company continues
to pay reparations to cancer and
mesothelioma victims.

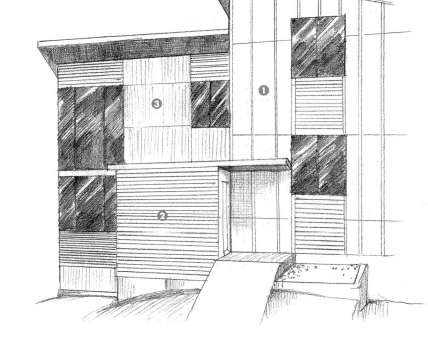

2. METAL

Three types of metal are used
for siding, either in smooth or
corrugated sheets: aluminum,
steel, and stainless steel.

ALUMINUM

Aluminum is the most light-
weight of the trio and is most
commonly seen in the form of
faux wooden clapboards on
1960s-era houses; today vinyl
has replaced aluminum in the
faux cladding market. Vinyl is
unequivocally terrible stuff and
is the source of many an archi-
tectural blight across America.
In the modern home, aluminum
is a good choice for coastal areas
because of its outstanding perfor-
mance against salty air.

STEEL

Steel is often pooh-poohed for its
propensity to rust. Although the
rust does weaken its integrity,
the brownish hue is appealing
to the eye and works well in gar-
ishly green tropical locales.

STAINLESS STEEL

Stainless steel is the most
sought-after modern material, as
it won't leave the telltale weepy
streaks from the rusted-out
screws used to secure the panels
to the framing. Unfortunately,
it's rather expensive. Moreover,
metal siding isn't very energy
efficient. Despite the waste cre-
ated in production, shipping,
and installation, and despite the
fact that it offers little insulation,
visually it's a knockout.

3. PLYWOOD

By far our favorite cladding
material, exterior plywood siding
usually comes in large four-foot-
by-eight-foot sheets that makes it
perfect to screw right onto the
house's frame. Unfortunately,
there are some downsides to
using plywood for exterior
siding. It's flammable and is
highly susceptible to rot if it
touches the ground or comes into
frequent contact with standing
water, making it a poor choice
for humid climates. Boards can
easily incur splits and cracks and
make a tasty treat for termites.
And yet, plywood siding remains
an incredibly popular choice for
modern dwellings, mainly because
it bridges the gap between preten-
sion and utility. No other material
simultaneously says, "I care
deeply what others think" and
"I care little what others think."

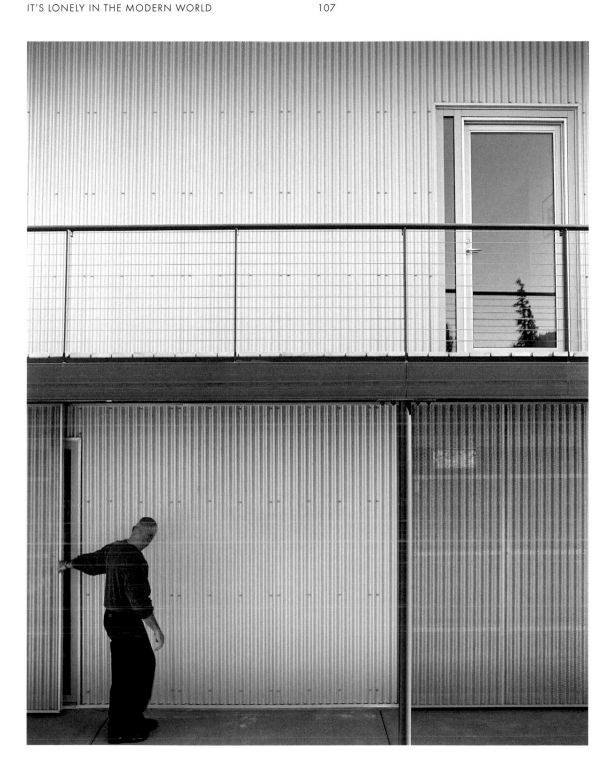

CASE STUDY #26

"The corrugated metal, like the Crocs, was meant to spite his
ex-wife. Yet, as in their marriage, he was the only one suffering."

A great building must begin with the unmeasurable, must go through measurable means when it is being designed, and in the end must be unmeasurable.

LOUIS KAHN (1901–1974)

Kahn's real name was Itze-Leib Schmuilowsky. An immigrant from Estonia, he didn't hit his stride stylistically until he was in his fifties. He had two children with his wife, Esther, plus two secret families including a daughter with his collaborator, architect Anne Tyng. He died of a heart attack in a public restroom at Penn Station in New York City. His body wasn't identified for many days because he had mysteriously crossed out his address on his passport. He died nearly penniless.

◉ Notable Works: Yale University Art Gallery. Salk Institute. Phillips Exeter Academy.

WINDOWS + DOORS

When early humans moved from caves to sod dwellings, they simply cut holes in the walls to let light in. Today, however, our windows and doors do more than offer interior illumination. A modern home is in tune with the visual, social, and spiritual aspects of its environment. Doors and windows act as portals: How we enter and exit the home, how we see in and how we see out, are all essential to creating a purity of form and mastery over the elements. They offer privacy, protection, and a connection with the natural world. Finding the style that best meshes with your overall aesthetic is essential. These windows and doors need to be strategically placed to frame views and maximize passive energy streams. The interior and exterior casings should enhance your home's architectural profile, not undermine it. And placement should lead the eye to areas where you've paid the most attention to detail—a winding drive, a stunning cement wall, or a xeriscape studded with native grasses.

Open Door Policy

A properly sourced door denotes a sophisticated command of two disparate languages, those of cool design and warm welcome. The right type of door creates a tight geometric precision that makes carefully considered details stand out in strong relief against the walls it punctuates. The door is more than just an entrance to your home—it's another opportunity to showcase your personality. Consider the door your first impression on the world: Do you want to be remembered as wooden and boring or stylish and sleek?

CONCEALED

A concealed door is designed to blend into the wall as if there isn't an opening at all. In a modern home, for example, a thick plywood panel would be set flush into the drywall. As a design element, it's minimally intrusive, requiring only a flat edge pull (rather than a cumbersome doorknob) for hardware. Some designs forgo hardware completely in favor of simply pushing the door open and closed. Concealed doors make use of a pivot hinge in the center of the door (rather than at a corner), which is invisible when the door is closed and allows it to fully swing open, perpendicular to the wall. Of course, without a locking mechanism on exteriors, it requires you to be open to pop-ins from unexpected guests and vagrants.

DUTCH

The Dutch door is an intriguing creature. Called a stable door in England, it was developed as a way to ventilate farmhouses while preventing livestock from entering the home. Essentially a door sawed in half horizontally at the middle, it manages to be both charmingly parochial and quintessentially modern. As with everything in the home, the materials used make or break this style. Done up with rugged wood and heavy hardware, it reads farmhouse. A modern interpretation uses resin panels or fiber cement planks in a bright CMYK color accented with stainless-steel accessories. It's an unexpected choice that makes it clear you are an adventurous and forward-thinking individual.

FRENCH

Usually, a French door is composed of two door-height casement windows (meaning they open into the room) that are joined by a single locking mechanism. Traditionally, French doors held many panes of glass, but to bring the look into the modern realm, we recommend adding variety by playing with the panes. You can turn each door into a single panel of glass or turn convention on its head and set the panes horizontally in a row of three or five. Framed in teak and opening out from the house, this is an excellent choice for single-family homes.

BARN

Agricultural architecture has become increasingly popular with contemporary architecture enthusiasts. Specifically, door panels set on sliding barn-door hinges have taken off in lofts that have been retrofitted from industrial to living spaces. The door panel is bolted to an upside-down U-shaped bracket that holds a small wheel. Placed on top of a grooved track mounted above the doorway, the panel slides to and fro. In an all-white minimalist interior, we suggest making a splash with a bright yellow door hanging from the wrought-iron hardware, or bring the style outdoors to create privacy for dining en plein air.

BROOKLYN

Far from a traditional door, a Brooklyn door features a simple exposed jamb without a panel. It's an absolute deconstruction of a "door." A Brooklyn door is best suited to indoor courtyards and outdoor showers. The exposure that comes with having an opening instead of a door is something that takes time adjusting to but ultimately brings about an enlightened sense of what is public and what is private.

CASE STUDY #588

"It was moments like this when, try as he might for a glimpse of genius, all he saw was the cruel clarity of crushed Cheerios."

Design is a plan for arranging elements in such a way as best to accomplish a particular purpose.

CHARLES AND RAY EAMES (1907–1978, 1912–1988)

These two win for cutest couple of modern design. Unfortunately, the timeline of their relationship is sketchy: He moved with his wife Catherine and daughter Lucia to study architecture at the Cranbrook Academy of Art in 1938. Ray arrived at Cranbrook to study "organic design" in 1940; she and Charles were married less than a year later. But who cares, when together they designed some of the most iconic houses and furniture of the day? They are perhaps the most well-known modern American designers, with their ubiquitous wood-and-leather lounge chair popping up in nearly every television show and movie since it was introduced. Ray died ten years to the day after her husband passed.

◔ Notable Works: Case Study House 8. Eames Lounger. La Chaise.

Pane Game

Fenestration presents the most complex design challenge in a home. The arrangement, shape, and size of the windows are as much a part of the interior as the furnishings and accessories used to decorate it. Likewise, the exterior of the home is most defined by the windows that punctuate the otherwise clean exterior of fiber cement, plywood, or corrugated steel.

1. SKYLIGHT

Inoperable windows that are set into the ceiling.

⊕ **PROS:** Minimally obtrusive, they can be combined with wall windows to flood a space with natural light.

⊖ **CONS:** Difficult to clean without heavily insuring your undocumented cleaning woman.

2. CASEMENT

Hinged at one side, a casement window can be set to crank open in or out of the home.

⊕ **PROS:** Works well over a kitchen sink or in the shower, where you would find it difficult to lean over and push up a window.

⊖ **CONS:** If it opens into the room, it compromises window treatments. However, in general, we strongly discourage window treatments of any kind.

3. PORTHOLE

A small circular window, sometimes called a bull's-eye, is usually fixed so that it doesn't open, just like on a boat.

⊕ **PROS:** Offers a very pleasing symmetry when used in a series, and can anthropomorphize a building.

⊖ **CONS:** Frequently read as beady little eyes. They are also pretty ineffective at framing views or letting in natural light.

4. AWNING

A rectangular window installed on the horizontal plane that is hinged on the top so it opens out.

⊕ **PROS:** Works well above a wall of floor-to-ceiling windows (which don't open) to create a breeze.

⊖ **CONS:** Requires keeping a ladder on standby to work the crank.

5. CLERESTORY

Installed at the very tip-top edge of where the wall meets the ceiling.

⊕ **PROS:** Clerestory windows are a favorite in contemporary homes because they allow light in without disrupting the interior architecture. They are especially useful in rooms with gargantuan ceiling heights.

⊖ **CONS:** None.

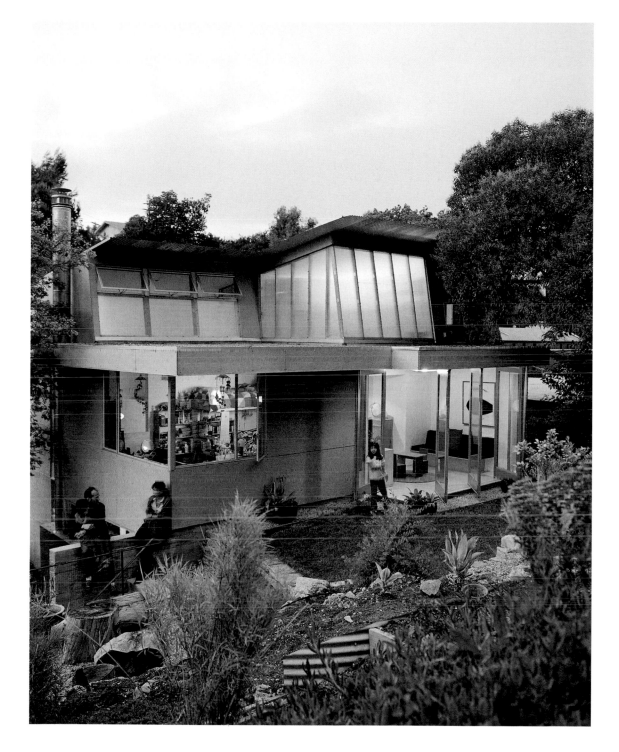

CASE STUDY #666

"Perched on the retaining wall, they devised a plan to outsmart the tyrannical child and her liege, The House."

GREEN SYSTEMS

At the most basic level, our homes protect us from the environment; in turn, it's our responsibility to protect the environment from our homes. Our homes consume and produce more fossil fuels and expel more emissions than gas-guzzling cars. For example, the average home puts out ten thousand pounds of carbon dioxide annually; compare that with a compact vehicle, which sends out a thousand or so pounds each year. While heating and cooling systems are integral to comfort, creating a temperate climate indoors can have a negative impact on the natural world. It's imperative to invest in eco-friendly alternatives, such as photovoltaic panels and passive solar cooling.

More advanced modernists take it beyond the solar panels: installing rainwater collection systems, mounting wind turbines on the roof, employing a troupe of goats to trim the lawn and shrubs. Sure it's expensive to be (even superficially) sustainable. If you can't afford to invest in turbines or gray-water systems, at least learn the terms and processes enough to speak with authority on the subject. In this section we've defined the vocabulary and outlined the essentials so you can choose which efforts to undertake and which ones you can safely stall on.

Eco-Chic

Even if you can't walk the walk, you should be able to talk the talk. Here you'll find a list of words and terms to bandy about in general conversation. As with any movement, there is a backlash advancing; stay ahead of the curve and read up on eco-brainwashing conspiracies and theories so you can speak sagely about how the "green" movement is (or isn't) really just a way to boost consumerism.

CRADLE TO CRADLE (C2C)

A product that is sustainable from manufacture to disposal. There are some carpets and flat-pack furniture that are rated Cradle to Cradle (C2C), including the packaging materials.

ENERGY STAR

A program developed by the U.S. government to rate everything from lightbulbs to washing machines according to energy usage. Extra points for scoffing that the rating is basically moot because it relies on manufacturers to self-report energy savings.

FSC-CERTIFIED

Short for Forest Stewardship Council, FSC is a rating that is given to woods that are supposedly sustainably harvested and manufactured. You can find everything from shingles to furniture made with FSC-certified wood. Like Energy Star, detractors point to the fact that many board members are actually the owners of companies that the FSC is rating, but at this point the certification is so ubiquitous as to be above reproach.

FLAT PACK

Furniture or other goods that arrive "ready to assemble" or packed flat. The idea is that the packed product cuts down on shipping, which is often the greatest source of emissions related to furniture manufacture and distribution. Consider how many tables can be shipped assembled versus the number that could be shipped in pieces.

GEOTHERMAL

This source of heat lies beneath the surface of the earth. It's considered 100 percent renewable. The energy is harvested through special high-density polyethylene coils laid under the ground that can then be used to power hot-water heaters and other systems.

GREEN

At this point, the word "green" can mean anything remotely eco-friendly. Used indiscriminately by marketers, a product with a minute amount of recycled content can be touted as green. You could ostensibly package a chemical pesticide in a recycled plastic container and call it green. For credibility, it's best to use "sustainable" in place of "green."

GRAY WATER

Waste water from laundry and bathing that can be recycled for irrigating lawns, hosing off concrete patios, and washing the Vespa. It can be unhygienic, however, depending on one's bathroom habits (e.g. shower urinators). It can be collected using a separate plumbing system from sewage water and immediately used for irrigation. If you store it in cisterns, you will need to invest in a device that treats the gray water for microbial bacteria.

HYDROPOWER

Energy derived from the movement of flowing water. In order to harness hydropower for the home, you need to have access to flowing water. Hillside locales are best, but a portion of a surging stream can be diverted to turn a turbine, which in turn powers a small generator.

LEED

Stands for "Leadership in Energy and Environmental Design." There are two sides of LEED. It's a points-based system for determining a home's environmental impact. It is also a label that is slapped on products such as paint, paneling, and carpet. Mostly a marketing tool for manufacturers to increase sales based on their item's perceived "greenness."

LOW-VOC

VOC stands for volatile organic compounds, which continue to release their gassy stench onto the world long after their initial use. VOCs include gasoline, acetone, and formaldehyde and are most often lurking in paints and other surface coatings. Look for low-VOC paints at your high-end paint purveyor.

PASSIVE COOLING + HEATING

These design features create comfortably temperate interiors without using fossil fuels. Methods include strategic window placement and installing thickly insulated walls.

PASSIVE HOUSE

Otherwise known as Passivhaus, this is a German standard for building efficiency that is totally voluntary and, being German, kind of severe.

PHOTOVOLTAIC

A technological system that converts energy gathered from solar panels into electricity.

POSTCONSUMER

A material that is recycled into something else after its original use is completed. For example, you might buy wall insulation made from recycled denim.

PRE-CONSUMER

Material that would otherwise be tossed during manufacture that is reworked into another product. Some snap-together flooring is made from pressed wood trimmings gathered from milling.

REMANUFACTURE

A used item that is taken apart, cleaned, and upgraded to be as good as new. You can buy remanufactured furnaces, for example, that are just as efficient as a freshly manufactured furnace. Remanufacturing cuts down on emissions by eliminating the processing of a new product. In a pinch, you can pass off most any product as remanufactured without anyone knowing the difference.

WIND TURBINE

A turbine (sort of like a windmill) that is powered by wind. There are residential models that can be mounted to the roof to capture wind power for home electricity consumption. However, to create enough energy to be worthwhile, the turbines need to be very large and very tall, which can detract from the carefully chosen roofline (refer to page 97 for more on rooflines). A mini turbine may not generate as much power, but it makes a statement about your (lukewarm) passion for fighting global warming.

ZERO ENERGY

A house or building that produces as much or more energy than it consumes.

A thing is right when it tends to preserve the integrity, stability, and beauty of the biotic community. It is wrong when it tends otherwise.

ALDO LEOPOLD (1886–1948)

The forefather of modern environmentalism, Leopold went on hikes with his fater in the woods of Iowa as a young child, which instilled in him a love of the outdoors. He's most famous for purchasing eighty acres of once-lush forest in Wisconsin that had been logged and deforested and turning it into an eco-haven. His book about the experience still sells tens of thousands of copies annually. Oddly enough, he was a big smoker and died from a heart attack fighting a fire on that same property.

⊙ Notable Works: *A Sand County Almanac* (book).

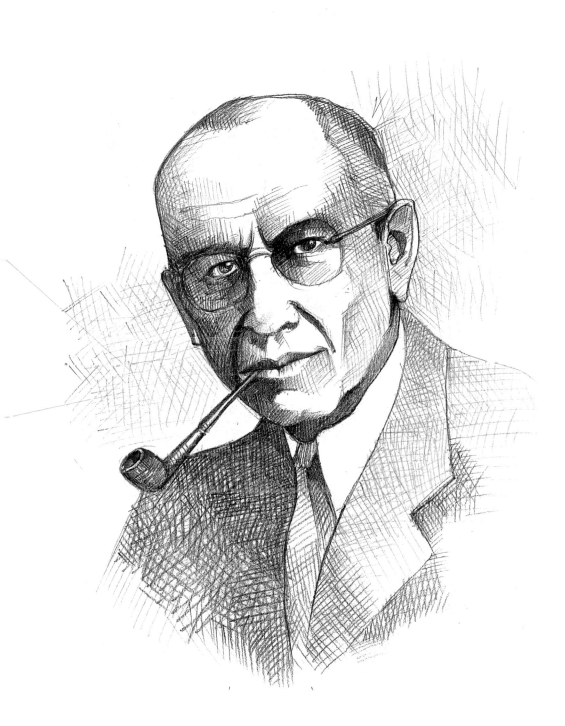

OUTDOOR FURNISHINGS

The interconnectedness between our outdoor and indoor living spaces is indisputable. Today's modern home should be equipped with ample space for outdoor entertaining, lounging, and thoughtful gazing. The more time we spend outside, the more effort and attention we need to give to designing our outdoor spaces.

Structures and finishes should harmonize with the surrounding flora and fauna. Furniture selection is crucial in creating a stunning, yet site-appropriate outdoor tableau. Whether your backdrop is an urban jungle or wooded rural vista, your decisions on outfitting the patio should be rigorous—no less informed and no less expensive than outfitting your interiors. Just because outdoor seating and tables are exposed to the elements doesn't make it okay to scrimp on style.

Lounge Around

In today's marketplace, you'll find a host of streamlined chairs made of synthetic materials with slim profiles. But not just any seat will do when it comes to creating an inviting atmosphere for outdoor entertaining. We've undertaken rigorous research into the comfort, form, and label recognition of countless deck chairs, benches, and chaise longues to bring you the top choices for outdoor seating.

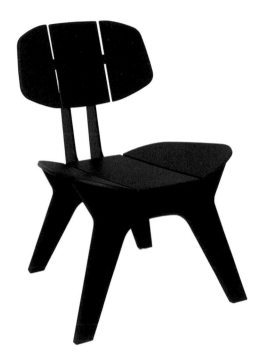

COCO CHAIR by Loll Designs

Reminiscent of the Eames molded plywood seat, this chair is made from 100 percent recycled polyethylene (that's plastic to you) from milk jugs and the like. It's also totally recyclable itself. The company, headquartered in a hip factory Loll calls "Hawks Boots" in Duluth, Michigan, offers the Coco chair in eight vibrant colors. The youthful hues and casual profile are ideal for arranging outside a prefab home.

DRAGNET CHAIR by Kenneth Cobonpue
for MOSS Outdoor

A graduate of Pratt, this Philippines-born designer's work has garnered acclaim with in-the-know design fans. This high-back seat features his signature take on his homeland's knotted and rattan furniture. Bright red and surprisingly lightweight, it's an excellent choice for modernists living in artistic coastal enclaves. However, it should be approached with caution by city dwellers, as it may skew too whimsical for the gravitas of an urban roof deck.

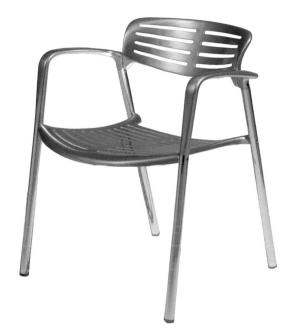

TOLEDO CHAIR by Jorge Pensi for Knoll

Pensi's work as an industrial architect in Barcelona has gained him many admirers. Made from thermo-treated aluminum polished to a glossy shine, the beauty of this chair is that it doesn't become hot to the touch—even during the harshest heat wave conditions. The chair is 100 percent recyclable. You may be tempted to add a seat cushion to the metal seat, but we advise against it. A pillow may be soft for your rear, but it detracts from the clean lines of the cutouts on the aluminum panels. Because they stack neatly in sets of four, this is the perfect chair for party throwers.

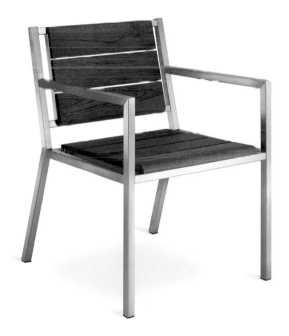

CASE STUDY CHAIR

For purists, this teak and stainless-steel confection is a true delight, realized in the most simple materials and elegant shape. The original pieces were manufactured as part of the Case Study Program, which ran from 1945 to 1966 and was sponsored by *Arts & Architecture* magazine. Major architects, including Charles and Ray Eames and Richard Neutra, were commissioned to create model homes for servicemen returning home to the United States. after the war. Today, reproductions of these furnishings are made in Los Angeles by Modernica. The most versatile outdoor chair, this seat is equally at home on a roof, in the yard of a prefab home, or on a slick concrete patio.

Architecture is the will of an epoch translated into space.

LUDWIG MIES VAN DER ROHE (1886–1969)

The son of a German stone carver, Ludwig Mies reinvented himself after his marriage dissolved in the early 1900s, adding his mother's maiden name "Rohe" and the Dutch "van der." He moved to the United States following Nazi pressure on artists to cease creating controversial pieces. His final masterpiece was to come full circle back to Germany with his "New National Gallery" in Berlin. Unfortunately, he was unable to attend the opening and died shortly thereafter.

❿ **Notable Works:** Barcelona chair, Farnsworth House, Plano, Illinois. Seagram building, New York.

Talking Points

Without the comforting enclosure of walls, many find shaping an outdoor living area bewildering. It's up to you to arrange the seating in your outdoor space to facilitate or prevent communication and interaction. Try the following seating plans to determine which formation complements your furniture, the square footage of your accommodations, and the sort of mood you wish to encourage.

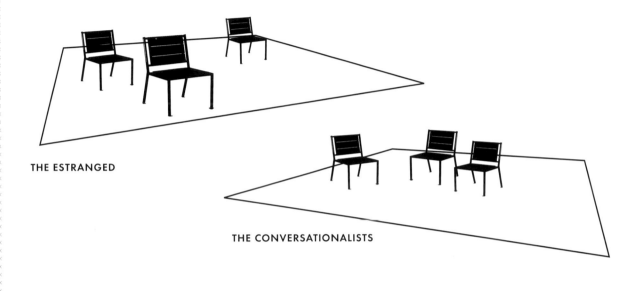

THE ESTRANGED

THE CONVERSATIONALISTS

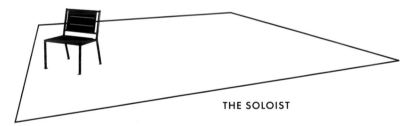

THE SOLOIST

PRACTICAL CONSIDERATIONS

Most people have become attached to the idea of "comfort" when sitting. With modern furniture, however, it's important to rethink your concept of what is comfortable. In a thickly cushioned chair, your body may be supported—but at what price to your design values? Your intellect? Your psyche? How comfortable are you with losing those aspects of self? It's better to focus on the pure joy and thrill of being close to high design than to slump into an overstuffed chair for a nap.

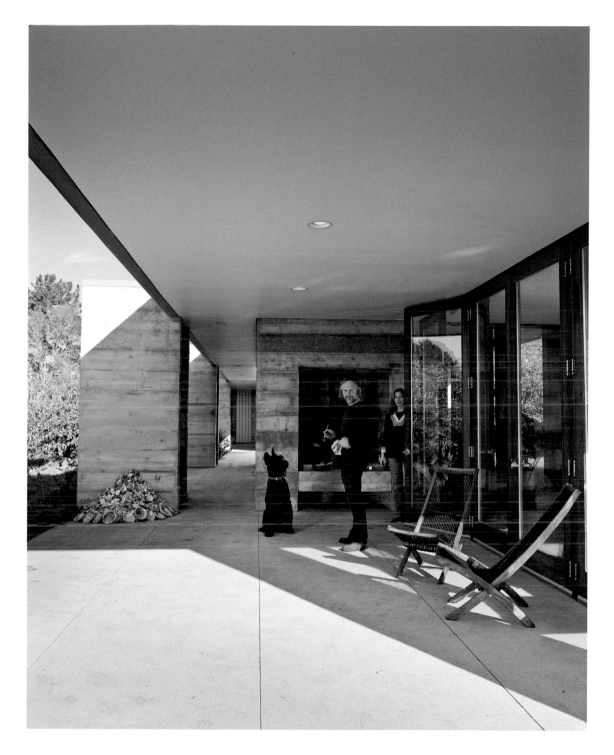

CASE STUDY #5692

"Even the dog was concerned when Sunday came and went
without a sacrificial bivalve added to the pyre."

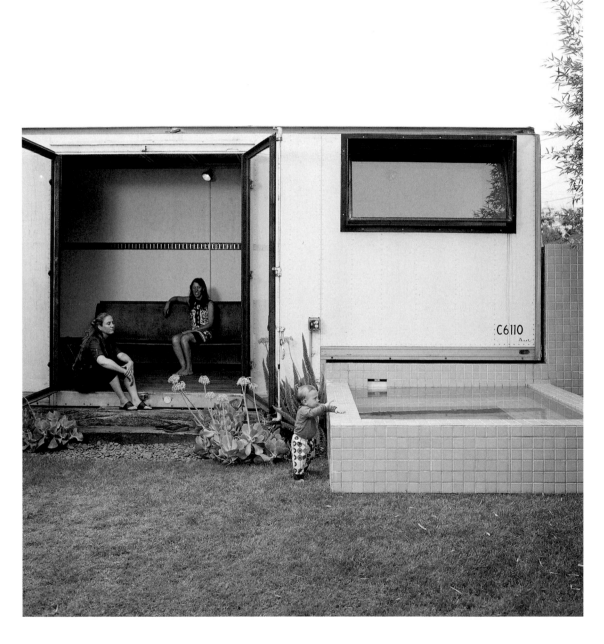

CASE STUDY #202

"The child could bear the boredom no longer."

LEISURE

With all the work to be done appointing your home, you may feel that leisure is a luxury that you simply don't have time for. But it turns out that leisure is more important than you may think. Scientists are forever unearthing evidence that supports the importance of adult play. Whereas children use play to learn basic life and interpersonal skills, adults rely on play to alleviate stress and to chase that ever-elusive state of being: happiness.

When designing your home and landscape, set aside an area devoted to outdoor recreation. We're not talking about football fields or volleyball courts. (Although if you do host a party that demands group athleticism, we find dodgeball to be the only game that offers the appropriate level of irony.)

Instead, there are water features and fire pits to consider. Lap pool or koi pond? Raised or sunken fire pit? And, of course, the most important question an outdoor-loving modernist can face: bocce or croquet?

Good Sports

House parties are infinitely enlivened by organized games. When warm weather allows, take the party outside for a spirited game of bocce, pétanque, horseshoes, or croquet. These games harken back to an earlier time, when evenings were spent enjoying vermouth-based cocktails and nibbling from tiny plates packed with pickled hors d'oeuvres. The right equipment is key; you can't make do with standard fare from a sporting goods store. Instead, take a few months to seek out vintage game sets at flea markets or on eBay. It should go without saying that teak is best. If you can't locate an authentic vintage teak set, it is possible to find pricey reproductions through online specialty retailers.

BOCCE

Since ancient Roman times, bocce has been the game of choice for leisure enthusiasts. Although most refer to the game by the Italian bocce, it's played worldwide under myriad names: *boule Lyonnaise* in France, *bochas* in South America, and *boćanje* in Yugoslavian countries. However, it's most often associated with elderly Italian men, making it the perfect game to be co-opted by hipster elites. It's played on a packed soil or asphalt court, with two players rolling hollow steel balls toward a smaller "jack" ball, which is used to start the game. The team with the most balls closest to the jack wins.

PÉTANQUE

This charming game began at the turn of the twentieth century in the south of France. Players gently hurl a number of hollow steel balls (*boules*) as close as possible to a small wooden target ball, called a *cochonnet* (French for "piglet"). Once all of the balls are tossed, the team with the most balls closest to the piglet wins. Although similar to bocce, in this game the balls can be thrown in the air, whereas in bocce they must remain on the ground. The style of pitching the ball and the court also differentiate the two; pétanque players toss their balls palm down and the court doesn't need to be flat like in bocce. In fact, pétanque can be played on any outdoor surface with minimal setup. Extra points for proper pronunciation: "pay-tonk."

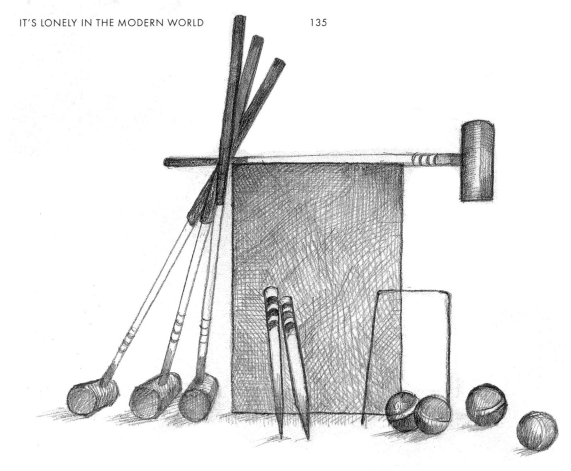

CROQUET

Croquet took England by storm in the mid-1800s but evidence suggests that it was played as early as 1600. This game of "ground billiards" has often been synonymous with out-of-touch bourgeoisie, but today the sight of a tattooed graphic designer in skinny jeans wielding a croquet mallet is deliciously anachronistic. The game itself is simple: Two to six players aim to tap their ball through a course of nine wickets. Extra points for boning up on croquet lingo. For example, a "bisque" is a free turn during a handicap match.

HORSESHOES

Deceptively easy, horseshoes is played with two teams of up to four people each. Players take turns throwing a horseshoe toward a spike set in the ground. A shoe that lands around the stake is called a "ringer" and garners the most points. However, players can rack up their score by merely throwing a shoe near the stake. Extra points for constructing your own setup of hillbilly horseshoes, in which the small metal washers used to connect nuts and bolts are tossed into the opening of a sawed section of PVC pipe glued into a wooden frame.

Organic architecture seeks superior sense of use and a finer sense of comfort, expressed in organic simplicity.

FRANK LLOYD WRIGHT (1867–1959)

A notoriously poor money manager who was accused of stealing ideas from subordinates, middle-aged Wright left his wife and six children for Mamah Borthwick Cheney, a married client. Mamah would eventually perish with her own children in Taliesin, the love nest Wright built for them, when a deranged household employee axed them to death and then burned the house with their bodies inside. Wright then became involved with a glamorous opium addict. Throughout, he won admirers with his organic style and became the first architect to design custom lighting and furniture for a residence. He lived to ninety-one with third wife Olgivanna, who decided his body should be exhumed, cremated, and interred with her and her daughter in Arizona. Today, his marked grave near his beloved Taliesin is empty.

◉ Notable Works: Fallingwater, Pennsylvania. Guggenheim Museum, New York. Taliesin, Wisconsin.

Liquid Courage

Water encourages contemplation, passion, and reflection. It's an essential element in any well-balanced outdoor area. You'll find yourself centered as you gaze at the ripples across a concrete-lined pool, listen to the dribble of a squat, square fountain, and glare at the sunken gravel pebble that plunked into the pond as a neighborhood child ran across the dry garden. Frankly, even beachside homes benefit from the calming energy of a subtle water feature. These pools don't need to be over-the-top Olympic affairs. Something clean and simple that offers a gentle trickle or a stagnant expanse will do.

PONDS

To make a statement, situate the pond on an elevated plateau, where a natural pond would be unlikely to form. Higher ground brings the added benefit of avoiding flooding during rainy seasons. Keep in mind that unless properly installed, a pond can imply Zen; lily pads and lotus flower will only make this problem worse. Children also may mistake it for a kiddie pool. Be sure to install a circulation system to avoid dangerous algae/mold growth.

WATERFALLS

Cascading waterfalls are a nice way to highlight a retaining wall. Use the slope to create an irregular path along which the water can travel, ideally following the linear outline of the wall itself. Create a channel inset on the wall; if the wall isn't on a slope you may need to install a water pump to encourage flow. You also may need to install a spout that delivers water from one level to the next. Under no circumstances should you consider an electronic "waterfall wall" or bubbling fountain spilling down a sheet of faux boulders. These features should be left in sushi restaurants and cheesy nightclubs, where they belong.

SWIMMING POOLS

In certain communities, swimming pools are de rigueur. But that doesn't mean you should compromise your values and design aesthetic. An aboveground monstrosity is never acceptable. (In fact, if your neighbors subject you to such eyesores, we suggest starting a petition campaign to ban these visual assaults.) Instead, a crisp rectangular pool lined with subtle, shimmering recycled glass tile is best. Pool patios can either be realized in great sheets of bluestone or a pattern of concrete pavers around which grow bright green grasses.

PRACTICAL CONSIDERATION

◉ Square concrete pavers set on concrete columns are the modern answer to new age stepping stones.

◉ Although swimming in your pool is appealing, it's best not to disturb the pristine surface, even if your lap pool is big enough for a college swim team. Splashing is unbecoming for the serious modernist.

◉ Your outdoor furniture choice will determine your water features. Refer to page 125 for guidance.

◉ Most city planning codes require hideous fencing be installed around pools to prevent small children from falling in and drowning. Either install the pool after the premises have passed the building inspection or erect temporary fencing you can remove postinspection.

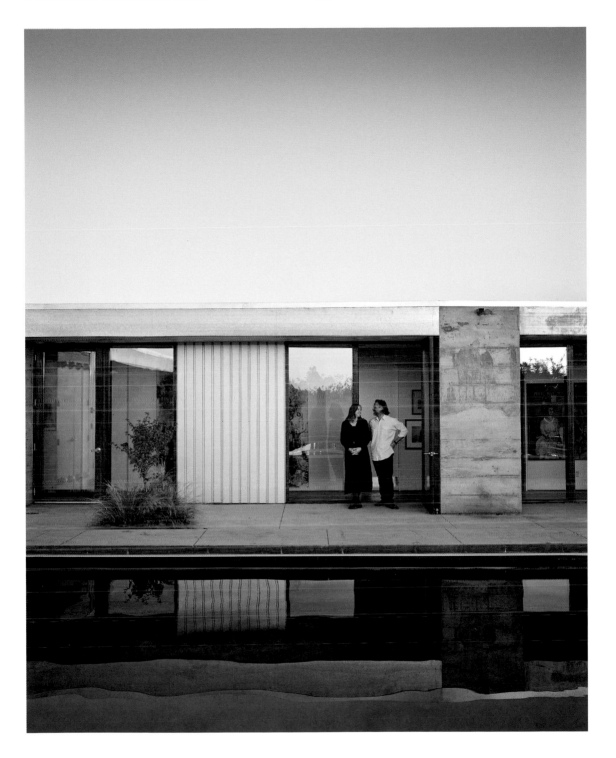

CASE STUDY #1112

"It wasn't funny then or now. The only difference was her ability to mask her rage."

Fire Starters

Since the dawn of time, fire has held a sacred place in the hearts and homes of humans. Even though we've mastered the art of managing and containing flames, from gas-lit stoves to indoor fireplaces that are lit with the flick of a switch, an undeniable urge compels us to sit 'round a fire at night (especially outdoors) with friends, sipping hot toddies and discussing the latest issue of *McSweeney's* or our favorite Rick Moody novel. The shadows cast on the walls, the fluttering flames, and the crackle of logs combine to create an intimate, mysterious atmosphere, heavy with longing for an earlier, simpler time.

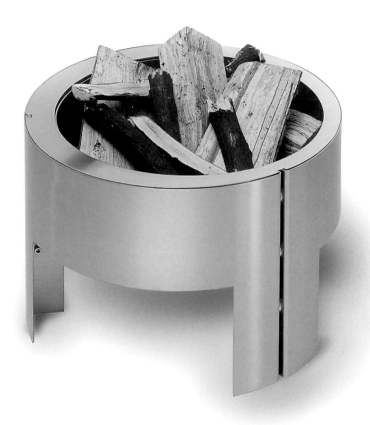

FIRE PITS

The vast majority of fire pits on the retail market are rustic metal barrels more fitting for a troupe of cowboys than a modern idealist. For a movable flame, invest in a stainless-steel fire "basket" (German manufacturer Blomus makes this excellent fire pit). These circular steel bowls are supported by tripod legs and offer a generous bucket for piling on firewood.

ETHANOL DEVICES

It's difficult to enjoy rooftop decks without the aid of some sort of lighting (aside from the cold glow of streetlamps). The temporal nature of a roof converted to outdoor living space precludes the installation of a permanent fireplace yet simultaneously calls out for the warmth and softness of natural firelight. Ethanol-fueled "fireplaces" offer a portable solution. They are available in a variety of sizes, from full-scale fireplaces to small compact models that flicker softly with a sad, solitary flame. These mini versions are best used in a series of three to nine to create a dynamic pattern of light that adds ambience to even the most desolate rooftop terrace. While you might not be able to ironically roast marshmallows and sausages on sticks, you will be able to stare into your soon-to-be estranged partner's eyes over the man-made flame.

OUTDOOR FIREPLACES

If you have an excess of space you can find unusual profiles that demarcate the untrammeled wilderness from your domain. To situate the fireplace, consider where the pattern of speckled light from the fire will be scattered and plan for a reflective surface as a backdrop, using materials like recycled glass tile (with discretion, of course). Here, a distressed finish may actually offer a lively interplay between slick concrete patio flooring and spiky agave plantings; allow the stainless-steel hearth to weather naturally. Over time the patina will develop into a dull, muted gray that is nearly impossible to achieve by artificial means. It goes without saying that it's essential to match the shape of your fireplace to the architecture of your home for visual cohesion.

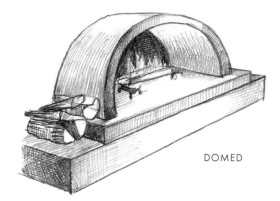

DOMED

BOXED

PRACTICAL CONSIDERATION

In order to cut wood into the appropriate size for piling handsomely into a pit, the logs must be split with a maul, sledge hammer, and wedge. The wedge is inserted into the top of the log and then pummeled to shear the wood apart. Among fire-starter enthusiasts, there is a general consensus that Australian pine is the finest wood available. You can purchase bundles of presplit Australian pine, but be sure to leave a wrought-iron wedge and maul in the firewood bucket to impress friends with your back-to-nature skills. Another alternative is to invest in New York–based KleinReid's sculptural set of white porcelain logs.

FLUTED

SECTION 3: ACCESSORIES

Even the most austere modern life can't be lived without at least a few trappings of consumer culture. Try as we might, it's impossible to avoid the reality that our homes are social spaces. The dining room is supposed to be dined in, regardless of how expensive and authentic the furnishings are. All this living comes with messy "things"—children to be molded, pets to be coddled, and choice collectibles to display. As the master of your own domain, it's up to you to control these accessories.

Choosing the select few things, people, and pets that will offset the unspoiled white walls and concrete floors should be a delight. These are the finishing touches, the final brush-stroke on the canvas of your life, in which nothing is precious and everything is purposeful. A journey through the rooms of your home should reveal a mixture of textures and forms. The gradient hues of white and gray should only be interrupted by a pop of color in the form of one stellar Finnish glass vase or a child's wooden blocks, beacons of color in a monochromatic maze. Robust steel and plywood are warmed by a handsome novel or a stack of magazines fanned out on the coffee table.

In this section, it's our aim to help you navigate the complex process of accessorizing your life. We'll zero in on what vintage periodicals and highbrow books should be displayed on your open shelving, help you determine whether you are a cat or dog person, suggest what kind of amplification will complement your vinyl and iPod purchases, and more.

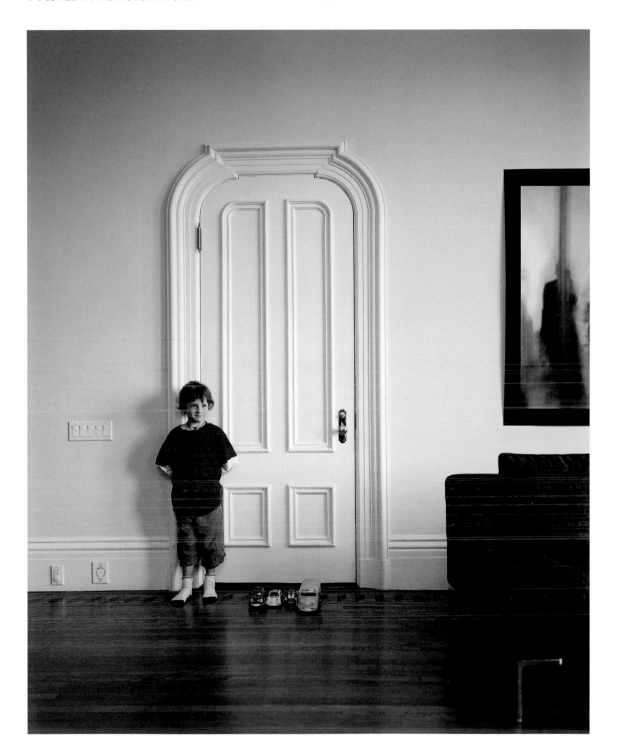

CASE STUDY #494

"Not even his adorable toy installation could distract from the muffled cries coming from the closet."

CHILDREN

Today we are seeing the first generation raised on feel-good, "you can do it" programming like *Sesame Street* rearing their own offspring. Neighborhoods once filled with pierced, tattooed artistes are now glutted with baby carriages and teetering toddlers. These modern parents cling to the notion that bearing a child won't change their lifestyle, making it common to see a baby in a bar in Williamsburg or a toddler waddling around San Francisco in a Pixies T-shirt.

Contemporary furniture manufacturers understand how important it is that your children fit into your modernist design aesthetic. A whole host of designers and manufacturers offer kiddie playpens made of blonde birch and retro toys designed by Eames, making it much easier for the modernist breeder to maintain a sleekly designed home. Despite the more sophisticated offerings on the market, a modern parent will find that they need to edit without sentimentality. You can't leave anything up to chance when it comes to child-rearing. It takes vigilance to keep Dora the Explorer and her ilk at bay.

We've compiled a list of the best modern names, toys, and accessories for turning out a modern kid. A child of your very own—it's a true extension of yourself and your particular design ethos.

All in a Name

Naming a baby is a wonderful opportunity to message your originality to the world. It's also a way to pass on the wealth of knowledge that can only come with decades of perusing record shops for rare Smiths 7-inches. If you shuddered each time a teacher called out roll and had to identify children as "Michael P." and "Michael C." then you can undo the pains of the past by giving your own tiny person the strong foundation of having an offbeat first name. Here are our top picks, with an emphasis on unusual spellings.

BOYS

Austin (alt: August)
Beau
Blue
Brooks
Butch
Cole
Django
Dixon
Gus
Jasper
Leopold
Leroy
Milo (alt: Miles)
Rian
Rufus
Silas
Simon
Theo
Zeke

GIRLS

Asher
Beau
Beulah
Billie
Blue
Cecilia
Coral
Dixie
Ella
Esther
Flannery (alt: Frankie)
Gladys
Hazel
Lila (alt: Lulu)
Mamie
Nell
Sunshine
Taryn
Zöe

TWINS

Eva and Eero
Charles and Ray
Mies and Eames

PRACTICAL CONSIDERATION

◉ If you're unsure whether a particular name works, imagine greeting a canine with the same moniker. If you can, it's a winner.

◉ Originality is essential. If you're having a hard time choosing from an established name, make one up by combining animal names and colors. For example: Leopard and gray become "Legray," while giraffe and teal become "Giraeal."

◉ A good rule of thumb is to err on the side of caution and choose a unisex name, especially those of exotic origin, like Kiran, which is traditional in India but highly original in Western nations.

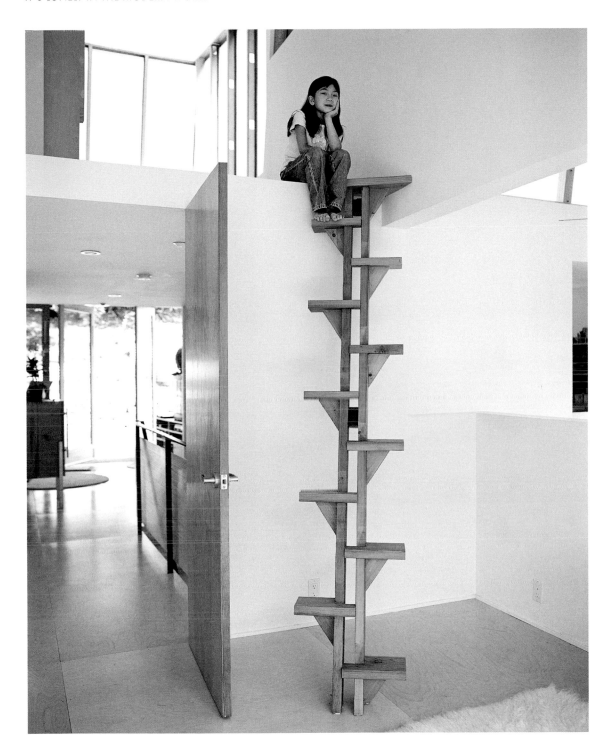

CASE STUDY #121

"When it was evident that her listlessness disrupted the family dynamic, heavily sighing became her favorite past time."

Learning Curve

Drawing from your own vast knowledge of kitsch and culture, choose toys that hint at both a tongue-in-cheek concession to the mainstream (a Mr. Potato Head doll perched on a dresser) and an elite understanding of design (graphic de Stijl-era giclées instead of flash cards). Only one company manages to straddle both territories: the group of American typeface desigers known as House Industries, lauded for their incredibly hip approach to graphic design. Inspired by midcentury designers, their fonts grabbed the attention of the Alexander Girard estate first, and then the estate of Charles and Ray Eames naturally came calling. The collaboration between House Industries and these two midcentury giants yielded sets of wooden blocks that will be the only playthings your child will ever need. However, to balance the clunky form of puerile blocks, invest in KleinReid's custom walnut tops for Herman Miller.

WALNUT TOPS

Three wooden tops created as a limited edition for Herman Miller by KleinReid, the working name of the collaboration between men-about–New York City artists James Klein and David Reid.

PRACTICAL CONSIDERATION

◉ When parents blather on about the benefits of Montessori schooling, one-up them with a serious discourse on the merits of the Reggio Emilia method, which suggests that the child's environment should be sparse and neutral to encourage their creative genius and natural leadership roles.

◉ Dress tots entirely in black and white to avoid the clashing colors so common in children's apparel.

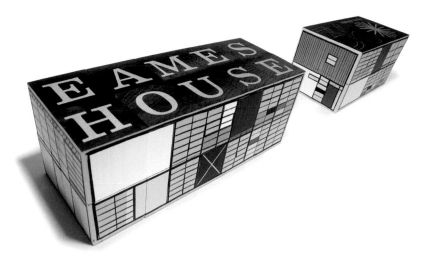

EAMES HOUSE BLOCKS

Thirty-six cubes featuring the alphabet, with patterns on all sides depicting sections of the Eames Case Study 8 house and studio.

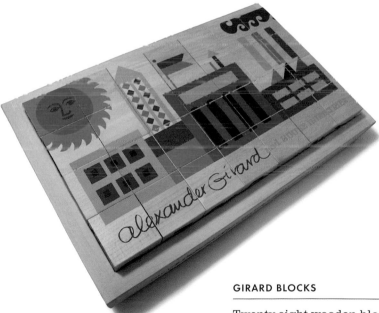

GIRARD BLOCKS

Twenty-eight wooden blocks inspired by textile designer Alexander Girard's signature bright patterns (primarily for Herman Miller, where he worked for decades), that combine to form a puzzle depicting a factory.

All architecture is shelter; all great architecture is the design of space that contains, cuddles, exalts, or stimulates the persons in that space.

PHILIP JOHNSON (1906–2005)

Johnson was a man of contradictions. A Nazi sympathizer who was an open anti-Semite in the 1930s and openly gay, he also founded the department of architecture and design at the Museum of Modern Art in New York. His boyfriend—art collector and Andy Warhol's best friend, David Whitney—was thirty-three years his junior. Together they were an artistic power couple, residing in the fourteen buildings at Johnson's estate in Connecticut where he built the "Glass House," which many see as a copy of his mentor Mies van der Rohe's Farnsworth House in Chicago. He lived to be ninety-nine; Whitney died of cancer a few months later.

◗ Notable Works: Glass House. Crystal Cathedral, California. Seagram Building, New York.

Sleeping Beauties

Unfortunately, small children aren't advanced enough to sleep in adult beds, necessitating special rigging to ensure that they don't tumble onto the concrete floor in the middle of the night and break a few bones. The main drawback to finding suitably modern bed frames for youth is that they tend to be garishly bright, in hot pinks and grotesque blues. Or, worst of all, covered in frightening licensed cartoon characters. Thankfully, modern parents now can find a few suitable options for youngsters with more refined sensibilities.

Brooklyn-based furniture maker Oeuf (it means "egg" in French—clever) offers a solid selection of simple wood-framed toddler beds, cribs, and changing tables painted white with a light-colored birch base. All their furniture is made with ethically sourced, FSC-certified wood and painted with only the finest nontoxic paints, so you can rest assured that little Genghis will be able to teeth on the railing without the risk of lead poisoning or the guilt of ravaged rain forests.

Oeuf's CLASSIC CHANGING STATION

The wooden tray sits on top of the crib frame when in use and is easily tucked away under the bed.

Oeuf's CLASSIC CRIB

Fixed wooden side rails painted soft white double as a graphic focal point.

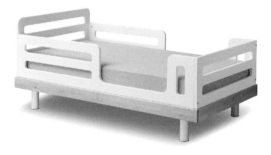

Oeuf's CLASSIC TODDLER BED

Purchase the accompanying organic mattress for added environmental credibility.

PRACTICAL CONSIDERATION

◉ A black-and-white palette will stimulate the child's senses and aid in brain development. We recommend painting the ceiling black to offer the child a sense of limitlessness as she falls asleep on her back. Also, it's better than the seizure-inducing cartoon-print wallpapers that are commonly used in nurseries.

◉ Carpet tiles from manufacturers like FLOR make a good surface for playtime. Not only do they prevent the little one from cracking his or her head open on the concrete floor, but they are easily packed up and tucked into a closet. They can also be used elsewhere in the house to prevent tots from soiling plywood surfaces.

◉ It can be difficult to find clothes hangers for children's apparel that aren't padded and covered with brightly colored fabrics. While an Eames hook might offer a solution, you can't hang all of a toddler's clothing from a few metal rods. Instead, head to a local welder and ask him to fashion miniature hangers using oxidized steel. It'll give an industrial edge to the pine pole in the child's closet.

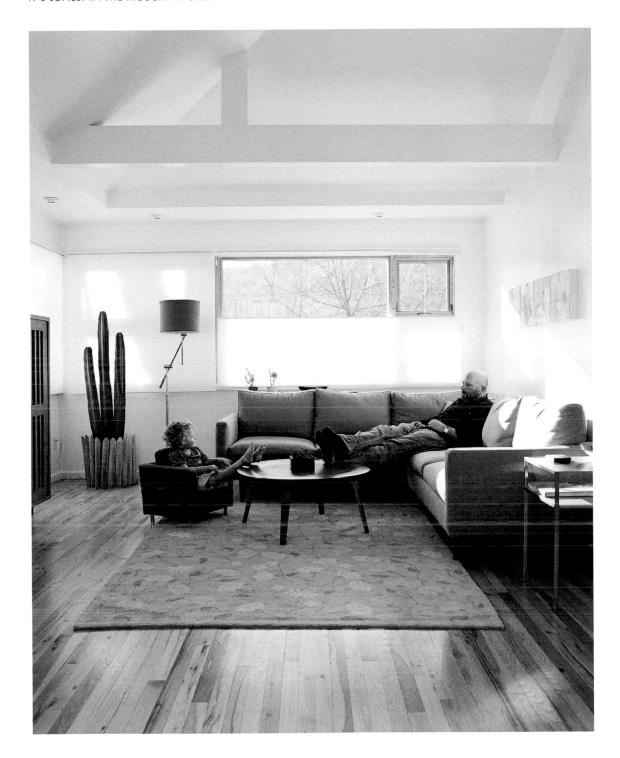

CASE STUDY #3892

"The debate—whether the ubiquity of suburban neo-modern developments was really an upgrade from new-money McMansions—ended in a standoff, mired by the generation gap."

Shrunk to Size

Contemporary design giant Knoll, the manufacturers of such classics as the Saarinen Womb chair, recognized the need for stylish children's furniture. The prices reflect the pieces' provenance. However, with such impressionable minds relying on you to choose the right seat, we've detailed the psychological impact of choosing the wrong seat.

Mies van der Rohe **BARCELONA CHAIR AND STOOL**

Slick steel and supple leather combine to create a genuinely sophisticated seat for a small child. It's not an overly comfortable seat for a baby, but you are assured that the kid will grow up to work in financial services.

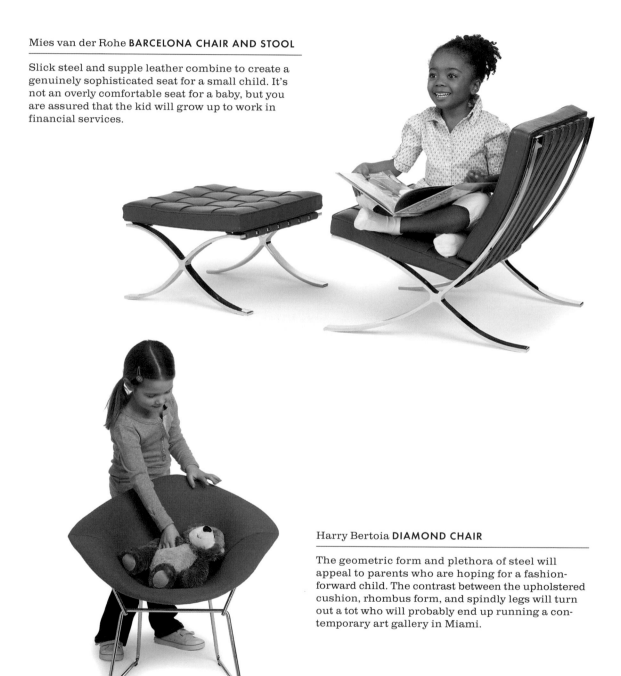

Harry Bertoia **DIAMOND CHAIR**

The geometric form and plethora of steel will appeal to parents who are hoping for a fashion-forward child. The contrast between the upholstered cushion, rhombus form, and spindly legs will turn out a tot who will probably end up running a contemporary art gallery in Miami.

Jens Risom **AMOEBA TABLE**

The table itself is a gorgeous undulating form that is well matched to a child's playful nature. However, the webbed seat should be avoided, as it will set the small one up for a lifetime of disappointment when he learns of the IKEA knockoffs and becomes an intellectual property lawyer.

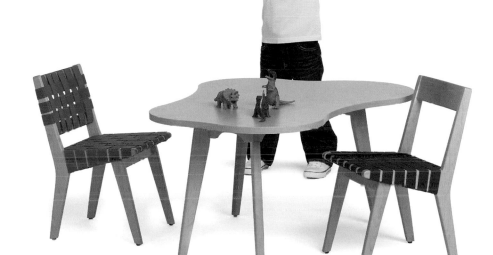

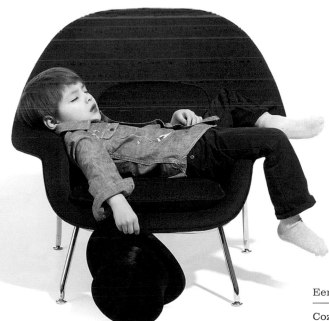

Eero Saarinen **WOMB CHAIR AND OTTOMAN**

Cozy and soft, this chair and the accompanying ottoman make the transition from in utero to interiors easier on a baby. Don't be surprised, however, if he or she grows up to be a behavioral psychologist.

BOOKS + MUSIC

Modernists tend to be ardent audio- and bibliophiles. Years of schooling and music festivals have instilled in you an uncommon attachment to books, music, and magazines. Unfortunately, these texts and tomes have no real value as decorative elements in a modern home. The books that changed your life, the books that colored your experiences on the path from prepubescent dreamer to self-aware adult, don't work as decorative elements. *What Color Is Your Parachute?* or *Zen and the Art of Motorcycle Maintenance* don't send the right message about your refined intellectual acumen. The Ani DiFranco CDs that got you through that horrific college break-up really shouldn't see the light of today. Instead, approach the curating of your in-home media library as a way to help others understand how you perceive the world around you and how the world should perceive you.

In this section you'll learn where to source and how to properly display music collections, books, and periodicals for maximum impact, and the contemporary gems worth a subscription (if only to splay artistically on the coffee table). This is the required reading and listening list for creating the illusion of a truly cultured mind.

Subscribers Only

The ephemeral quality of a printed magazine is what gives periodicals their charm. Each lasts just a short while before the next edition is on newsstands. With the impending death of print, it seems that all the great magazines have given in to advertorials (paid content meant to look like original editorial) or, worse yet, have dumbed down what few pages are left to appeal to wider audiences. Either way, these publications usually alienate the few loyal readers that are still willing to whip out an arcane checkbook to mail in their subscription. That's why we suggest cultivating a collection of vintage magazines.

SCANDINAVIAN JOURNAL OF DESIGN HISTORY

VOLUME ELEVEN · RHODOS INTERNATIONAL SCIENCE AND ART PUBLISHERS

SCANDINAVIAN JOURNAL OF DESIGN HISTORY is the only design publication that has a place on the coffee table, where the most current issue and a dog-eared back issue should be casually displayed. This annual publication began in 1991. A thick collection of essays and critiques by authors and historians, it's featured such luminous works as "Constructivism and Children's Books in Soviet Avant-garde Propaganda Art," written by Tatiana Saarinen. The journal is produced by Danish publisher Rhodos. For maximum effect, purchase all of the back issues and stack them within easy view of visitors.

SPLAY LIKE A PRO

How to artistically splay? You start with a stack of no more than five magazines and then use the heel of your hand to gently push the top magazines away from the spine of the base magazine.

The bright yellow spine of a **NATIONAL GEOGRAPHIC** magazine is always at home on the shelves of a modern abode. Finding older editions can be difficult, especially if you want to aim for authenticity and display only the issues that featured heavy typography on the covers, before they began running photo covers in the early 1960s. Your best bet is to troll eBay, estate sales, and flea markets to reach a full set.

INDUSTRIAL DESIGN magazine (later known as the initialed *I.D.* magazine) was founded in 1954 as a way to chronicle happenings within the industry. The late, great graphic designer Alvin Lustig served as art director, with Jane Thompson (wife of Ben Thompson and an accomplished architect in her own right) and Deborah Allen as coeditors. Andy Warhol drew illustrations. John Gregory Dunne was an editor. It switched to *I.D.* in the 1980s to reflect a broader depth of coverage, making the Reagan years your cutoff for collecting. The magazine shuttered for good in 2009.

SWINDLE was started by graffiti legend Shepard Fairey and his cohorts. Before the bimonthly arts and culture magazine stopped publishing in 2009, it featured work by everyone from Henry Rollins to Damien Hirst, along with interviews with Billy Idol and Grandmaster Flash. You can purchase back issues online at the Swindle website, Swindlemagazine.com.

PRACTICAL CONSIDERATION

If you can't live without a television and DVD player, make sure to prominently position one box of the six-volume set of films by Charles and Ray Eames, which were made between 1950 and 1982. Topics range from the Mexican traditional holiday the Day of the Dead to DNA molecules. Invite a date over to watch, or set up a viewing party with friends, to showcase your breadth of knowledge and depth of interests.

Required Reading

There are two kinds of books in a modern home: private and public. Certain books you keep on the coffee table or open shelving and certain books you conspicuously stack in threes on your bedside table. To say that the bedroom books are private only means that they are the books that give insight to your innermost values, not that they are kept secret. Instead, they offer a way for visitors to sneakily glimpse your true self when they poke around your bedroom while ducking into the bathroom. Meanwhile, the books on your coffee table should stimulate conversation, while the select tomes on the shelves should hint at a deeper understanding of art and science.

INTERNAL EXISTENTIAL DISCORD
The Plague by Albert Camus

SCIENTIFIC SOCIAL CONSCIOUSNESS
The Empathic Civilization by Jeremy Rifkin

JADED POST-PUNK MEMOIR
We Did Porn by Zak Smith

STREET CRED
Blek le Rat by Sybille Prou

SENTIMENTAL KITSCH
Toy Instruments by Eric Schneider

HOMAGE TO THE PAST
Design Research by Jane Thompson and Alexandra Lange

$4,500 WORTH OF CONSPICUOUS CONSUMPTION
Goat: A Tribute to Mohammed Ali (Greatest of All Time) by Benedict Taschen

HOMAGE TO THE MAN
Le Corbusier: Le Grand by the editors of Phaidon

BUTCHNESS
Popular Mechanics guidebooks

ARTISTIC THEORY
Interaction of Color by Josef Albers

CARTOGRAPHY
Atlas Major of 1665 by Joan Blaeu

QUICK ANSWERS
Set of vintage *Encyclopædia Britannica*

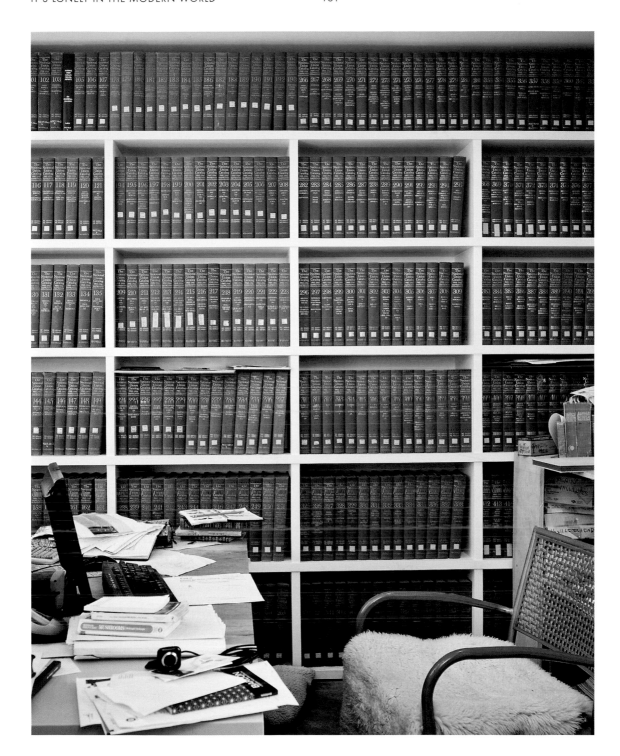

CASE STUDY #11

"He'd spent years cultivating a perfectly messy study. So to find that someone had stuffed a red volume on the umber-only bookshelves? Well, the proverbial shit hit the fan."

Man loves everything that satisfies his comfort. He hates everything that wants to draw him out of his acquired and secured position and that disturbs him. Thus he loves the house and hates art.

ADOLF LOOS (1870–1933)

This Austrian-born architect became a major critic of the art noveau style of the period, instead praising minimalist modern architecture and decoration that was devoid of ornament. Unfortunately, he contracted syphilis at twenty-one from a brothel and had a series of unhappy marriages before he had to have part of his stomach removed due to a cancerous tumor. After that, he could only eat ham and cream. Deaf at fifty, a pedophilia scandal destroyed his reputation before he died, broke and alone, in Vienna at sixty-two.

◐ Notable Works: Steiner House, Germany. Goldman & Salatsch Building, Austria.

Static Pulse

Appreciating music is a skill that isn't easily learned. It takes time and dedication to understand the dulcet tones of gypsy guitarist Django Reinhardt. And it takes even more time to harvest a superior collection of vintage vinyl and bone up on the catalogs of underground independent musicians that support your design ethos. You may encounter an occasional hiccup (everyone has a Moby CD stashed somewhere), but soon, after some trial and error, you'll develop controls (no electronica) that will guide you in the process.

More important than the playlist, though, is what it's played on. We offer solutions for sound systems that will both complement your decor and enhance your listening experience. There are only two options when it comes to audio enjoyment: throwback vinyl magnified with extremely rare wood-cased, fabric-covered speakers or delightfully ironic high-tech send-ups.

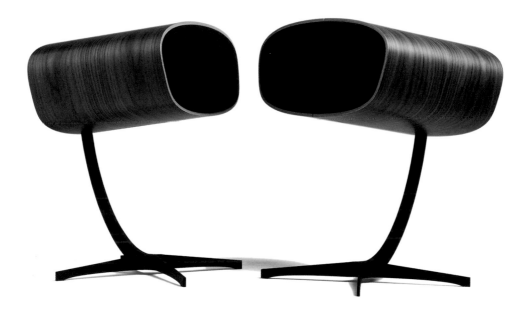

DAVONE RAY

These bentwood speakers are set on top of a curvaceous steel stand. Together, they are a passive pair, requiring an external amp to power the sound. Made in Denmark, each stands about thirty inches high with the walnut-veneer speaker case measuring a good twenty-three inches wide. They also cost ten times as much as their boxy counterparts. Don't be fooled by these lightweight speakers—they may be only twelve pounds apiece but they are monsters of sound with 150 watts of power.

PRACTICAL CONSIDERATION

True modernists will seek out the Eames Quadraflex. This boxy speaker was first designed by Charles and Ray Eames in 1957 for the now defunct Stephens Tru-Sonic brand. It's about thirty inches high, sitting on four legs and wrapped in the same bentwood as an Eames lounger. The speakers are wildly difficult to find and can fetch up to $2,000 each, whether they are in working condition or not.

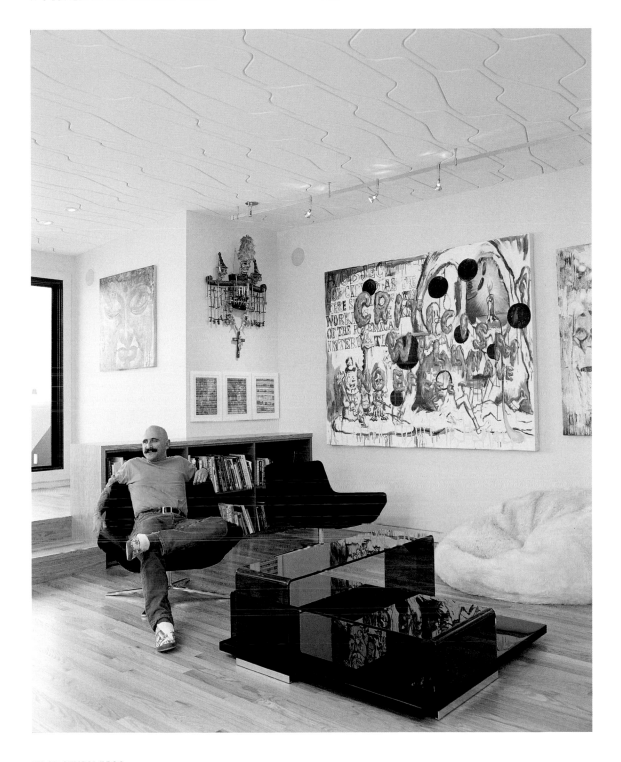

CASE STUDY #508

"She could always count on her creepy uncle Leo to blast bad house music and generally overstay his welcome."

PETS

If children aren't an option, a pet will do. Canines have lived with humans for at least fifteen thousand years, helping our forebears to hunt and stay warm, and protecting them from predators. All that time getting to know one another has paid off: No other animal can recognize human behavioral cues as well as dogs (even better than some humans). By the time the first dog show was held in late-nineteenth-century England, dogs had moved from workers to status symbols. Today, man's best friend is just as subject to judgment as any other accessory, so we've created an easy-to-use chart for finding the right breed for your home.

Cats, on the other hand, present a difficult challenge, in that they play by their own rules and aren't as easy to parade about town. A scientific study determined that the difference between cat and dog people is exactly what you think: Cat people are neurotic and dog people are social and easygoing, regardless of gender. Since declawing is patently inhumane, only homeowners with concrete and steel interiors should risk cat ownership, lest the feline fiends tear a vintage Knoll sofa to shreds. (Unlike kitties, a dog can be trained to stay off the furniture.)

Whichever animal companion you choose (and we strongly advocate for dogs), they do require special habitats. A variety of beds, kennels, and scratching posts are featured on the following pages, including styles that will accommodate even the most serious minimalist.

Breeding Ground Rules

Dogs come in so many shapes, sizes, colors, and textures, that it can be hard to believe they are actually the same species. Here we help you simplify the process of choosing the right canine for your lifestyle. Adoption should be your first avenue for securing a pet, so that you can smugly tell friends and neighbors that he/she is a "rescue," but if the shelter doesn't stock an ideal match (this is especially true for the more exotic varieties) then head to a reputable breeder.

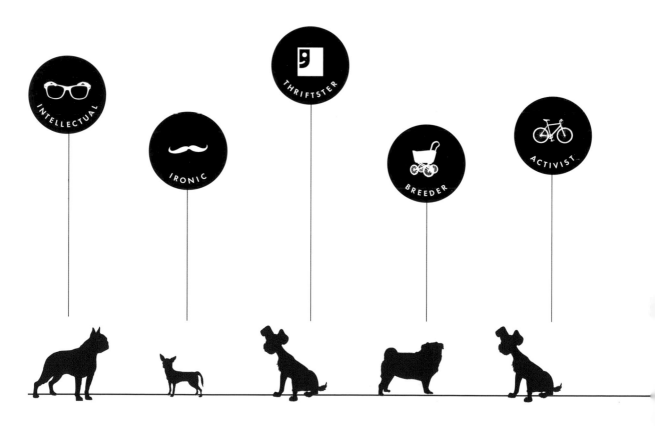

| BOSTON TERRIER | CHIHUAHUA | MUTT | PUG | MUTT |

PRACTICAL CONSIDERATION

For a list of suitable names refer to page 146. Otherwise, you can simply name the pup "Chien." Extra points for making his/her middle name "Andalou" after the surrealist Salvador Dalí movie of the same name or "Andalusia" after the Pixies song "Debaser," which was inspired by the film. Even more points for teaching the dog to come when you yell, "Slicing up eyeballs!"

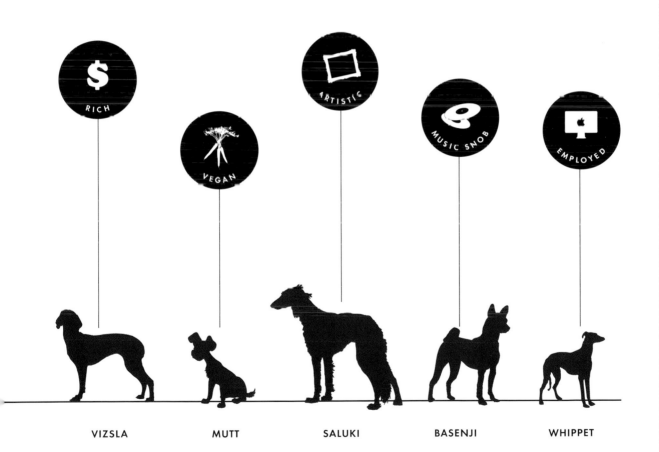

RICH · VEGAN · ARTISTIC · MUSIC SNOB · EMPLOYED

VIZSLA MUTT SALUKI BASENJI WHIPPET

Modern architecture does not mean the use of immature new materials; the main thing is to refine materials in a more human direction.

ALVAR AALTO (1898–1976)

One of the most prolific and famous modern architects, Aalto had a career that spanned the 1920s to the 1970s. He designed buildings, textiles, furniture, and glassware. Perhaps because most records kept on Aalto are in Finnish, there is little available information about his personal life, aside from his two seemingly happy marriages. Both wives were architects; the second worked in his office as an assistant.

◉ Notable Works: Aalto vase for Ittala. Three-legged stacking stool. Essen Opera House, Germany.

Sleeping Dogs

Dogs and cats require special sleeping areas. To ensure that their bedding is in keeping with the design schema of the house, we combed specialty pet stores and boutiques to find superior, well-designed products. These pet beds promise to serve their animals without providing visual distraction for owners.

FATBOY DOGGIELOUNGE

Finnish designer Jukka Setälä first created the Fatboy as a contemporary beanbag chair. The brand has since branched out into hammocks and dog beds. The Doggielounge is filled with tiny polystyrene balls and is easy to wipe clean. Plus, it is available in classic Marimekko patterns.

KITTYPOD

This corrugated cardboard bowl sits on a four-legged maple X-shaped base. Artist Elizabeth Paige Smith created the bed/scratch post for her cat Simon. Today she's turned the design into a successful business run out of Venice, California.

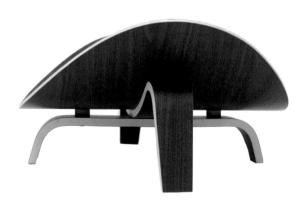

HOLDEN DESIGNS

Unhappy with the selection of dog beds and feeders available in pet stores, architect Jon Wesley Rahman started Holden Designs. His creations include a raised dog bowl and this bentwood bed frame reminiscent of the Eames molded plywood chair.

PRACTICAL CONSIDERATION

Cat litter pans are unsanitary and unsightly. No matter what kind of shredded pine or ceramic chip litter you fill it with, the ammonia scent of feline urine is hard to mask. If it's at all possible, train your pussy to use the toilet. (It may take less time if you've plunked down for one of the more high-tech commodes that flush themselves.) If potty training isn't happening, line the pan (ironically of course) with British tabloids.

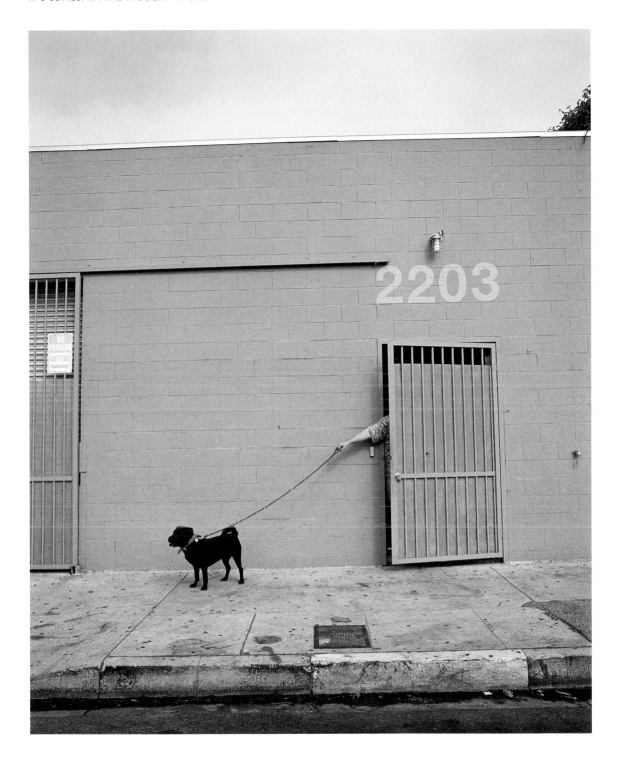

CASE STUDY #1106

"He'd hoped to procure one of the elusive 'silver' pugs; this mutt stuck out like a sore thumb."

EPILOGUE

Concessions to the Ideal

Now that you've finished reading this book, you have a veritable arsenal of ideas, strategies, and techniques for creating a modern home. Although you may have the tools to achieve the modern ideal, it's just as important to understand that minimalism requires concessions and that there are exceptions to most rules.

You can learn a lot from books, but there's no substitute for real-life experience. A student who's memorized a driving manual can't suddenly embark on a road trip without logging serious miles with an instructor. So before you can erect a truly modern home, it's necessary to take a detailed look at the journey of a well-known modernist. Perhaps one of the best known minimalist homes in the United States is Philip Johnson's "Glass House" in New Canaan, Connecticut (see page 150 for more on Johnson), making it a perfect case study for explaining the concept of concessions.

A pal and protégé of Mies van der Rohe, Johnson noted his mentor's obsession with creating a building made entirely from steel and glass—without any solid "walls" to speak of, so minimal as to almost be invisible. Mies (as his students and friends called him) spent five years, from 1946 to 1951, designing and building the "Farnsworth House" on a sixty-two-acre estate outside of Chicago as a country retreat for client Dr. Edith Farnsworth. Johnson built his version of the see-through house in 1949.

So what can we learn about these two landmark structures, aside from the fact that you should never trust a sycophant who eagerly promotes your talent, while secretly harboring jealousies?

The Farnsworth house exists as a single, one-room structure. Johnson's property in New Canaan features fourteen other buildings on the forty-seven-acre property. That's right, fourteen different buildings, in which Johnson and his boyfriend, David Whitney, did all of their actual "living."

There is the "Brick House," a rectangular guesthouse adjacent to the Glass House, that holds all of the mechanicals to power both buildings, as well as an extra kitchen. The brick facade was supposed to be a counterpoint to the glass walls; it also hides the unsightly utilities. Nearby is a circular swimming pool.

There was a long lull in construction on the property. But then Johnson met Whitney in 1960, and the building frenzy began.

In 1962 Johnson built a pavilion around a square man-made pond where the couple could entertain guests outdoors, sip cocktails, and bask in the sun. In 1965 he built the subterranean "Painting Gallery" in a hillside, where he kept their extensive art collection, including a portrait of Johnson by Whitney's best friend, Andy Warhol. In 1966, the couple bought "Popestead," a late 1800s farmhouse that they remodeled during the next forty years, using it as a summer residence for family and friends, sometimes living in it themselves. In 1970, Johnson designed and built the "Sculpture Gallery," which holds six floors of work by extremely high-profile artists.

In 1980 he built himself a studio, which looks like an upside-down cone, where he kept all his architecture books. In 1981, Whitney purchased "Calluna Farms," where he lived; the walls were remade using the same pink stone Johnson sourced for his AT&T building in Manhattan. In 1984 they erected a steel-chain structure called "Ghost House," which he and Whitney filled with lilies. In 1985 he installed the "Lincoln Kerstein Tower" (named after a writer who founded the New York City Ballet with George Balanchine), a chunky obelisk that is tricky to climb.

In 1995, in either a desperate bid for relevancy or a pathetic acquiescence to pop culture, he built "Da Monsta," a crazy red thing that he intended to serve as a visitors' center for the property when he died. In 1999, he and Whitney remodeled the "Grainger," an eighteenth-century Shaker building that they updated to include an oversize window with a graffiti print etching by artist Michael Heizer. The Grainger was painted a custom shade of black created by Donald Kaufman, (a famous colorist) and the couple used it to watch television and drink tea. And, of course, they had apartments in Manhattan.

It's said that each evening Johnson would walk around Da Monsta and pat it, no doubt content that he'd cemented his place in history. It's also said that when Mies van der Rohe first saw the Glass House, he stormed out of the building in a furious huff. And once, a wild turkey ran through a wall of the Glass House, shattering it completely.

The lesson: Don't have jealous friends or live near flocks of roving wild turkeys. And if you just can't let go of your book collection, then it's only logical to build a house for it. Or if you need a place to kick back and watch reality television, build another house. If your boyfriend is a world-famous art collector, build another house. And if you can't figure out where to stash the circuit board and furnace—you guessed it— build another house. Because the only way to become a true minimalist is to be conspicuously maximalist.